PATRICK PEARSE

A LIFE IN PICTURES

**BRIAN
CROWLEY**

MERCIER PRESS
IRISH PUBLISHER – IRISH STORY

For my parents

MERCIER PRESS

Cork

www.mercierpress.ie

© Text: Brian Crowley, 2013

ISBN: 978 1 78117 133 2

10 9 8 7 6 5 4 3 2

A CIP record for this title is available from the British Library

Printed and bound in the EU.

CONTENTS

ACKNOWLEDGEMENTS

With thanks to my friends and colleagues in the OPW and in particular the staff of Kilmainham Gaol, Derrynane Abbey, The Pearse Museum and St Enda's Park. Particular thanks to Niall Bergin, Anne Marie Ryan, Conor Masterson, Liz Gillis, Mícheál Ó Doibhlin, Delia Hickey, Mary Heffernan and Matthew Jebb. Thanks also to Glenn Dunne and the staff of the National Library of Ireland, Lar Joye, Finbar Connolly, Paul Doyle and the staff of the National Museum of Ireland, Niamh McCabe, Donal Fenlon and the Royal Society of Antiquaries of Ireland, Sharon Sutton and Trinity College Library, Audrey Drohan and UCD Library, Ken Bergin and the Glucksman Library at the University of Limerick, Lady Davis-Goff, the late Deirdre O'Reilly, Noel Scarlett, Elaine Sisson and Sinead MacDonagh. For help and advice thanks to David Maybury, Tim Carey and Catherine O'Connor. For years of conversations and pondering about Pearse, thanks to Pat Cooke. Special thanks to my IT saviour, Cillian Hogan, to Jonathan Callan for the beautiful photographs, to the unceasingly supportive Crowley family and the always wonderful Stephen Boylan. Finally, thanks to Mary Feehan, Wendy Logue and all at Mercier Press.

INTRODUCTION

The legacy of photographs and other images associated with the life of Patrick Pearse is particularly rich and varied. At a time when photography was a new and expensive technology, Pearse's father arranged for pictures to be taken of both his family and the works produced by his stone-carving business. Pearse grew up beside his father's workshop, and the statues of fantastical angels and saints carved from solid blocks of stone gave the young boy a keen awareness of the power of images. His imagination was further stimulated by his father's collection of illustrated books, magic lantern slides and the engravings of famous artworks which adorned the walls of the family home.

In early photos Pearse has the appearance of a dreamy child, lost in his own world. He retains this air of detachment as a schoolboy in the Christian Brothers School on Westland Row in Dublin. He appears isolated from the other boys, though not necessarily lonely. He never managed to look completely at ease in photos taken with other people, with the exception of those featuring him with his beloved brother, William (commonly known as Willie/Willy). Some of Pearse's awkwardness in group photographs stems from his self-consciousness about a squint or 'turn' he had in one of his eyes. From his teenage years on he rarely allowed himself to be photographed in any way other than in profile. He carefully controlled how the camera, and posterity, would see him. The profile was also associated with the depiction of heroic figures, including Robert Emmet, the leader of a rebellion against British rule in Ireland in 1803. Pearse admired Emmet above all other Irish historical figures and may have welcomed the opportunity to emulate his legendary pose.

In 1908, when Pearse came to set up his experimental, Irish-speaking Scoil Éanna, he sought to recreate the kind of aesthetically rich surroundings which characterised his own childhood. He filled the school with historical and contemporary art. He hoped that his 'educational adventure' would inspire Irish society and be adopted as a prototype for a new, child-centred and specifically 'Irish' form of education. With that in mind, he made sure that the activities and achievements of the school on the sports field and the stage were professionally photographed and publicised. When Pearse moved the

school to the stately surroundings of The Hermitage in Rathfarnham at the edge of the Dublin Mountains, he was at pains to emphasise the grandeur and inspirational nature of the school's new home and had a series of photographic postcards produced showing the school's most attractive features.

Scoil Éanna failed to transform Irish society in the way Pearse hoped it would, and he was increasingly drawn to revolutionary politics from 1913 onwards. Pearse, wearing the uniform of the Irish Volunteers, became the public face of militant Irish separatism. In August 1915 he gave an oration at the grave of the Fenian revolutionary Jeremiah O'Donovan Rossa, an occasion during which his image was captured on film for the first and only time. It was Pearse who proclaimed the new Irish Republic outside the GPO on Easter Monday 1916. The final photograph of him was taken six days later when he surrendered to the British Army in his capacity as commander-in-chief of the rebel forces.

Following his execution, Pearse's profile became one of the most identifiable symbols of the 1916 Rising. It assumed an iconic status and contributed to a sense of Pearse as an otherworldly being, no longer a man but an image carved in stone. In the debates over his reputation which began in the 1970s he became either a holy symbol to be defended at all costs, or the target of a radical iconoclasm. However, the images which accompany this history demand that we look beyond the monumental profile and examine the complex and fascinating figure who lies behind it.

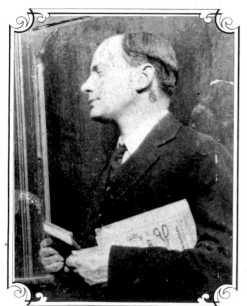

Note: All images are courtesy of Pearse Museum/OPW unless otherwise indicated.

Left: Pearse holding a copy of the May 1913 edition of *An Macaomh*. (Image courtesy of the University of Limerick)

'THE QUIET PLACES IN WHICH MY CHILDHOOD WAS SPENT ...'

Patrick Pearse was born on 10 November 1879, the second child and eldest son of James and Margaret Pearse. He was born in a back room of 27 Great Brunswick Street (now Pearse Street), above his father's stone-carving business. At that time most of the house was rented out to tenants; the Pearses occupied just three rooms – a bedroom on the first floor where Pearse was born, and a kitchen and living room in the basement. As his father's business prospered they eventually became the only occupants of the house.

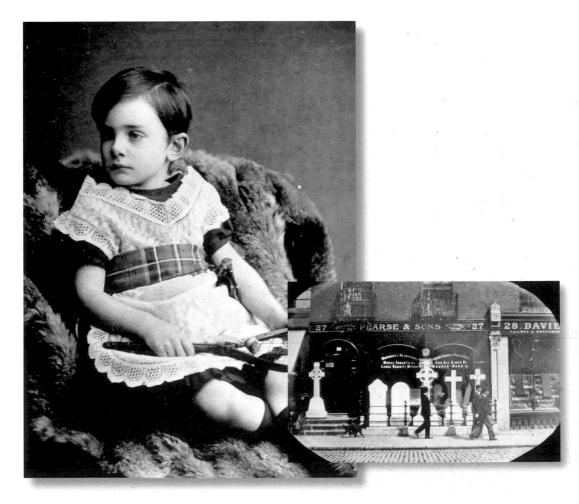

Pearse's father, James, was born in London but grew up in Birmingham. He came to Dublin as a journeyman stonemason in the wake of the boom in church building which resulted from the achievement of Catholic Emancipation. He married his first wife, Emily Fox, in Birmingham in 1863 and they had four children together: Emily (b. 1864), James Vincent (b. 1866), Agnes Maud (b. 1869) and Amy Kathleen (b. 1871). Neither Agnes Maud nor Amy Kathleen survived infancy and, according to Patrick, James blamed his wife for at least one of their deaths. The marriage was not a happy one. Emily Snr died in 1876 and James married Pearse's mother the following year.

James met his second wife, Margaret Brady, less than a year after the death of his first wife. She was just nineteen when she met James, who was seventeen years her senior. She worked in a paper shop around the corner from his premises on Great Brunswick Street. Her father was a coal factor in Dublin, but originally hailed from County Meath. She was a traditional, pious, well-mannered girl, with a limited education.

This manuscript image comes from an autobiography which Pearse began in his thirties but never completed. The fragment which survives covers only his very early childhood. In it he writes about his family background and how his mixed heritage set him apart. This sense of cultural and social insecurity was to stay with him all his life. He concludes his description of his parents' families by saying:

For the present I have said enough to indicate that when my father and my mother married there came together two widely remote traditions, – English and Puritan and mechanic on the one hand, Gaelic and Catholic and peasant on the other; freedom loving both, and neither without its strain of poetry and its experience of spiritual and other adventure. And these two traditions worked in me and, fused together by a certain fire proper to myself (but nursed that fostering of which I have spoken), made me the strange thing I am.

Note how he crosses out his original description of himself as 'an Irish Rebel' and replaces it with the much more ambiguous 'strange thing I am'.

References: Patrick Pearse, 'Fragment of Autobiography' (PMSTE.2003.0946); Pat Cooke, 'Patrick Pearse, The Victorian Gael', in Roisín Higgins and Regina Uí Chollatáin (eds), The Life and After-Life of Patrick Pearse, p. 45

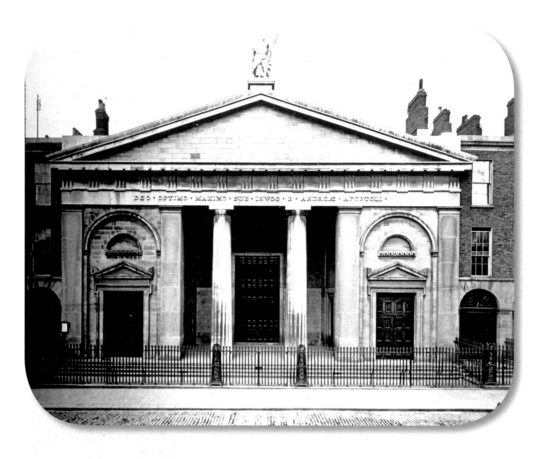

Pearse's grandfather was the favourite brother of his great-aunt Margaret Brady and his mother was her favourite niece. For that reason she was desirous that her niece's first boy be named Patrick after his grandfather. His second name, Henry, came from his father's younger brother. According to Pearse's autobiography:

> Auntie Margaret carried me to the Chapel – to St. Andrew's Westland Row – to be christened; it was she too who registered my birth in the public register. She omitted the name of Henry in registering me, and years after my father had to make a declaration that Henry was part of my name, and that the correct spelling of the surname was Pearse, not Pierce …

The above image of St Andrew's Church is from the Pearse family's own magic lantern slide collection.

Reference: Patrick Pearse, *'Fragment of Autobiography'* (PMSTE.2003.0946)

Although he was only two years old, Pearse vividly recalled the birth of his younger brother, Willie:

> What greater thing has ever happened to me than the coming of that good comrade? Willy and I have been true brothers. *Willy's companionship has been the one solace of my sorrowful life.* As a boy he has been my only play-mate, as a man he has been my only intimate friend. [Words in italics were deleted by Pearse]

The picture shows Mrs Pearse with Willie on her lap. Like many children at the time, he was dressed in what would now be considered girls' clothes during his early years.

Reference: Patrick Pearse, '*Fragment of Autobiography*' (PMSTE.2003.0946)

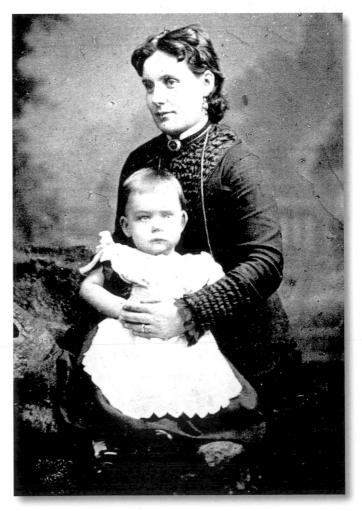

Pearse also had two sisters. Margaret was one year older than him, while his younger sister, Mary Brigid, was born in 1884.

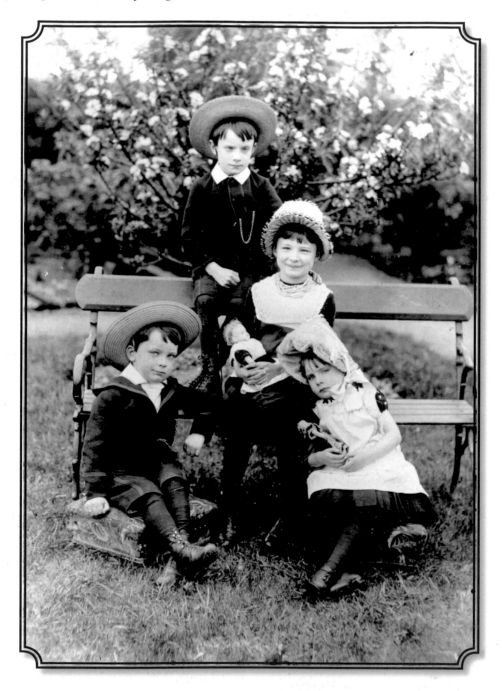

Left to right: Willie, Patrick, Margaret and Mary Brigid Pearse.

Patrick's half-sister Emily married in 1884. Her husband was an architect called Alfred McGloughlin. He was the son of John McGloughlin, a friend of her father's. The two families were very close, and when James Pearse's first wife had grown seriously ill, John McGloughlin had taken the Pearse family into his home at 5 Parnell Place, Harold's Cross, Dublin.

Patrick was the page at Emily's wedding and recalled wearing a claret-coloured velvet suit with white socks and a deep lace collar: 'I held up my step-sister's train as she walked from her carriage into the church and up the church, and back again.'

Emily and Alfred's marriage eventually broke up and she moved to Donegal, where she worked as a midwife. When she retired she returned to Dublin and lived in Emmet's Fort, a lodge in the grounds of Scoil Éanna in Rathfarnham.

Reference: Patrick Pearse, '*Fragment of Autobiography*' (PMSTE.2003.0946)

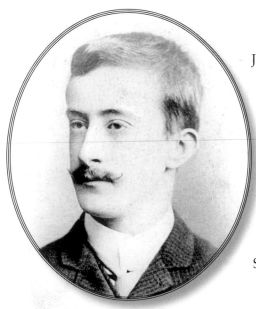

James Vincent Pearse followed his father into the family business. He continued to work for the family firm for a few years after his father's death, but seems to have had little contact with his father's second family prior to his early death in 1912. (Images courtesy of Pearse Museum/OPW, with thanks to Noel Scarlett)

Pearse is photographed here as a very young boy holding a toy gun. He was doted upon by his mother and his great-aunt Margaret, who stayed with the Pearse family for long periods. She fired his imagination with her tales of ancient Irish heroes like Cúchulainn, Fionn Mac Cumhail and the Fianna.

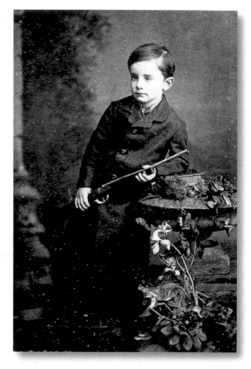

She also told him about more modern figures like Wolfe Tone, Robert Emmet, the Fenians and O'Donovan Rossa. It was from her that Pearse developed his passion for the Irish language.

He recalled one occasion when both he and Willie were dangerously ill with scarlatina. They were living by the sea in Sandymount at the time and Auntie Margaret came to care for them. Pearse recalled her beautiful singing voice soothing him when he could not sleep. She knew many songs about men who died or went into exile for the love of Ireland. She also sang ballads about Napoleon, in particular 'The Old Grey Mare'. Pearse later published this song along with an additional stanza which he had composed himself.

Pearse retained a fascination with Napoleon. This print of Napoleon on campaign in 1814 by Jean-Louis Ernest Meissonier was one of many relics and mementos of Napoleon that Pearse owned.

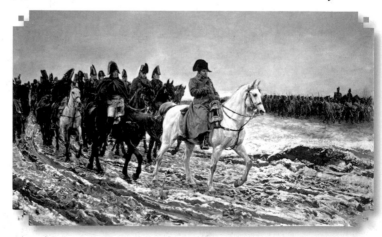

Reference: Patrick Pearse, '*Fragment of Autobiography*' (PMSTE.2003.0946)

James and Margaret Pearse were married for twenty-three years. James' bohemian tendencies are reflected in his somewhat unconventional choice of headgear in this picture. In his autobiography, Pearse speaks about occasional visits by his father's bohemian and artistic friends, who would wear quaint costumes and would sometimes sketch or paint the young Pearse, 'sometimes of my head only and sometimes of my whole body without any clothes on'.

Reference: Patrick Pearse, '*Fragment of Autobiography*' (PMSTE.2003.0946)

Seated, left to right: Mrs Margaret Pearse, Mary Brigid Pearse, Margaret Pearse. *Standing*: Patrick Pearse, James Pearse, Willie Pearse.

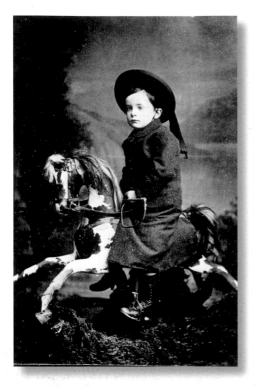

When he was very young Pearse's father carved him a wooden horse, 'as gallant a steed as ever knight errant rode'. He built him 'five hands high, giving him mighty limbs and a proud head and a fiery eye'. The horse played a key part in the fantasies and games of the Pearse children. Pearse occasionally pretended to harness him to a 'state coach' and draw his sister Margaret into imaginary cities. Other times he would imagine pacing mournfully with a hearse and coffin behind him to Glasnevin Cemetery. Most often Pearse rode him alone 'in quest of some Holy Grail'.

Reference: Patrick Pearse, '*Fragment of Autobiography*' (PMSTE.2003.0946)

The Pearses were imaginative children and Patrick often wrote plays for them to perform. They were frequently joined in these dramas by their orphaned cousins, Mary Kate and John Kelly, who were the children of their mother's sister, Kate Kelly, and came to live with the Pearses. There is little evidence to suggest that they had many other intimate friends outside the family circle.

Tragedy was to strike the Kelly family again in 1902, when John was killed while cycling home.

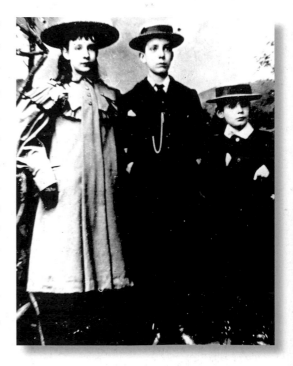

Left to right: Mary Brigid Pearse, Willie Pearse and John Kelly.

Pearse was particularly close to his cousin Mary Kate. As children, they were fascinated by trams and trains and would spend their pennies travelling between College Green and Westland Row. This image of College Green, Dublin, is taken from a lantern slide in the Pearse family collection.

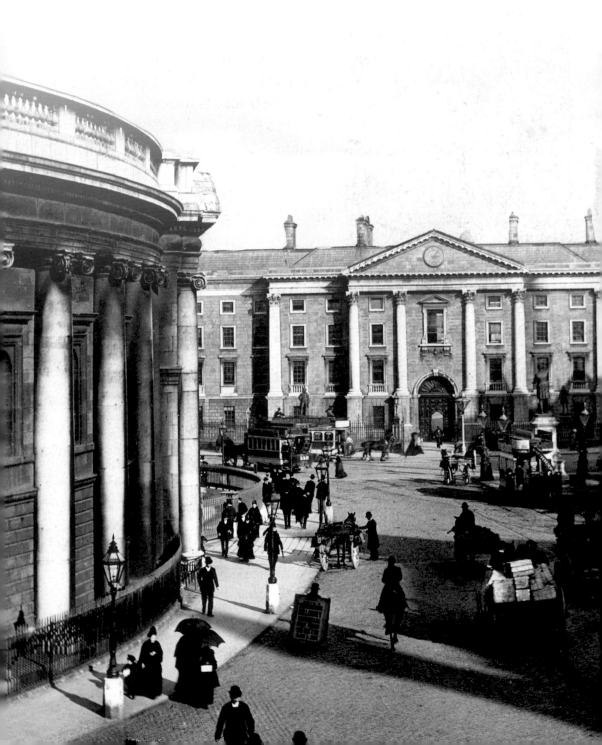

Later on, while Mary Kate was at boarding school, Pearse wrote to her remembering 'the jolly times we spent at Grandfather's – playing in the hay loft, swinging in the yard, and hiding in the bedrooms. Those days I reckoned among the happiest of my life.'

Mary Kate married Sydney Shovelton and settled in London. She is pictured here as a young married woman. Due to the breakdown in the communication systems following the Rising, she found out about Pearse's involvement and his subsequent execution from the newspapers. Shortly afterwards she wrote to the remaining family saying, '[that my] own dear Pat had been shot was too awful. How on earth has it all come about? And what awful madness possessed him? Still, whatever I think, I know that he was possessed of none but the highest ideals, and my love remains unchanged.'

References: Mary Brigid Pearse (ed.), *The Home-Life of Pádraig Pearse,* pp. 113–14; Ruth Dudley Edwards, *Patrick Pearse: The Triumph of Failure,* p. 329

Growing up alongside the family sculpture business, Pearse remembered the rhythmic tap-tapping which came all day from the workshop. He said he could eventually distinguish the different sounds of the chisel against soft Caen stone and the much harder marble. (Image courtesy of Deirdre O'Reilly)

Reference: Patrick Pearse, '*Fragment of Autobiography*' (PMSTE.2003.0946)

James Pearse's business thrived throughout Patrick's childhood. James often had his work photographed and made into magic lantern slides. One example (*top right*) shows a depiction of the marriage of the Virgin Mary and St Joseph.

James Pearse's work brought him all over Ireland and Britain. A Celtic Cross memorial to Rev. Michael O'Donoghue was erected in Kilronan on the Aran Islands in 1893. James' most significant secular sculpture was commissioned by the National Bank of Ireland in 1889 during the period of his partnership with Edmund Sharpe. It depicted the National Bank's trademark and featured a female classical figure representing Ireland resting her hand on an Irish harp, accompanied by a wolfhound (*bottom right*). She is surrounded by barrels, bolts of fabric and sheaves of wheat to signify the commercial wealth of the country. It can still be seen on the roof of 34 College Green.

The success of James Pearse's business meant that Patrick and his siblings enjoyed a comfortable childhood. Here the family are seen on a excursion in what is presumably a hired carriage.

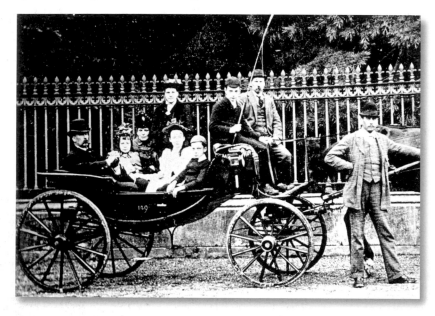

While the Pearse family were prospering, they were surrounded by some of the worst slums in the city. This picture shows Plunkett Cottages, a slum just off Townsend Street, which backed onto the Pearses' premises on Great Brunswick Street. (Image © Royal Society of Antiquaries of Ireland)

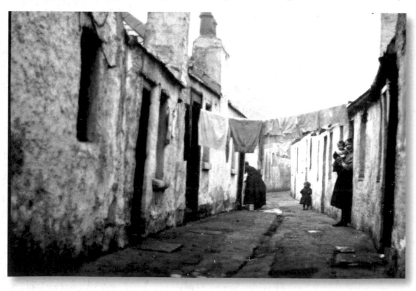

In his autobiography Pearse describes moving to 3 Newbridge Avenue in the middle-class suburb of Sandymount when he was seven years old. James Pearse added a Gothic arch to the house which has not survived, and the Pearse children enjoyed playing in the large garden and field opposite. They lived in the house for a relatively short time and returned to 27 Great Brunswick Street in 1888. This may have been related to increased demands on James Pearse's finances, resulting from the break-up of his business partnership with Edmund Sharpe that year. (Image courtesy of Jonathan Callan)

References: Patrick Pearse, 'Fragment of Autobiography' (PMSTE.2003.0946); Joost Augusteijn, *Patrick Pearse: The Making of a Revolutionary*, p. 38

As a young boy, Patrick was determined to purchase a magic lantern machine and saved up his pocket money until he was able to buy one. Unfortunately the cheap machine he bought did not work when he got it home and had to be abandoned. However, on his next birthday his father presented him with a new working machine and a set of slides. Patrick subsequently gave regular illustrated talks to his family.

The magic lantern would later play an important part in Pearse's school. Illustrated talks by Pearse and visiting lecturers were a regular feature in the life of Scoil Éanna. Two surviving examples of his collection of slides are shown here which feature images of Glendalough, County Wicklow, and the Custom House in Dublin.

Pearse's early school days were spent in a private school run by a Miss Murphy. Among other things, she taught the Pearse children how to waltz. In 1891 Patrick and Willie were sent to the Christian Brothers School (CBS) in Westland Row.

Pearse was a quiet, serious and studious pupil. He rarely joined in with the other boys' games and seemed somewhat aloof to them. One of his classmates, Éamonn O'Neill, later wrote that he would often climb onto a high window ledge of the school and sit there reading a book alone.

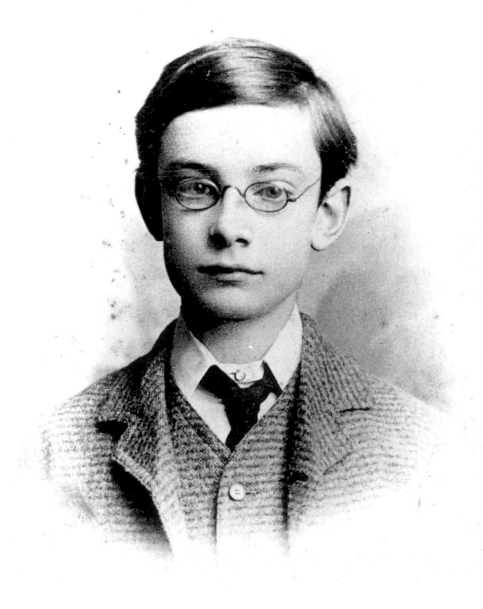

Pearse was a hardworking and diligent student. He performed well in the State Intermediate Examinations and is seen in this picture seated among the intermediate exhibitioners and prize winners of Westland Row CBS in 1893.

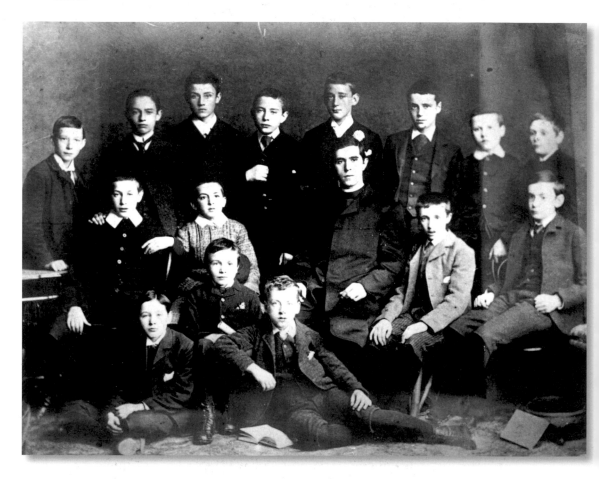

Standing (left to right): P. Caroll, E. A. Murray, Éamonn O'Neill, T. Murray, J. M. Byrne, E. J. Power, J. A. Duffy, J. Carr.
Seated, middle: P. Ryan, W. Penny, Brother Walsh, P. Fitzgerald, P. H. Pearse.
Seated, front: M. Ryan, M. Keegan, J. Curran.

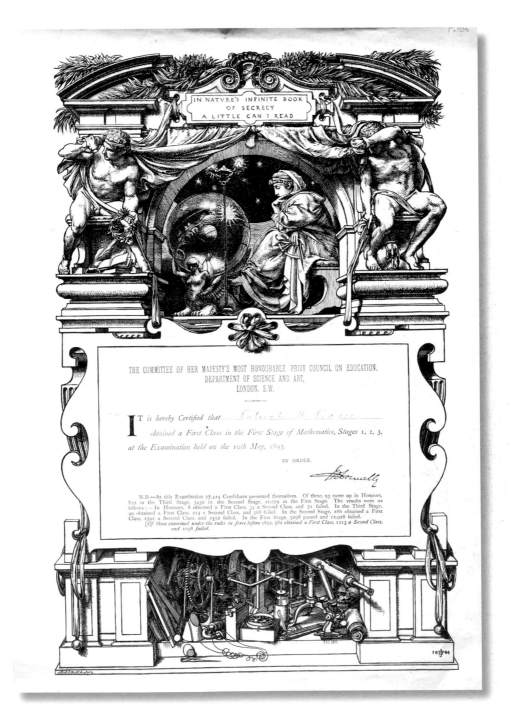

THE COMMITTEE OF HER MAJESTY'S MOST HONOURABLE PRIVY COUNCIL ON EDUCATION,
DEPARTMENT OF SCIENCE AND ART,
LONDON, S.W.

I^T is hereby Certified that *Patrick H Pearse*

obtained a First Class in the First Stage of Mathematics, Stages 1, 2, 3,

at the Examination held on the 10th May, 1893.

BY ORDER.

N.B.—At this Examination 27,424 Candidates presented themselves. Of these, 93 came up in Honours, 822 in the Third Stage, 5430 in the Second Stage, 21,079 in the First Stage. The results were as follows:—In Honours, 8 obtained a First Class, 54 a Second Class, and 51 failed. In the Third Stage, 40 obtained a First Class, 214 a Second Class, and 568 failed. In the Second Stage, 286 obtained a First Class, 2592 a Second Class, and 2552 failed. In the First Stage, 5298 passed and 12,928 failed. [Of those examined under the rules in force before 1892, 582 obtained a First Class, 1213 a Second Class, and 1058 failed.

This is the certificate awarded to Pearse by the Department of Science and Art on his achievement of a First Class in the First Stage of Mathematics, Stages 1, 2 and 3, in the State Intermediate Examination in May 1893.

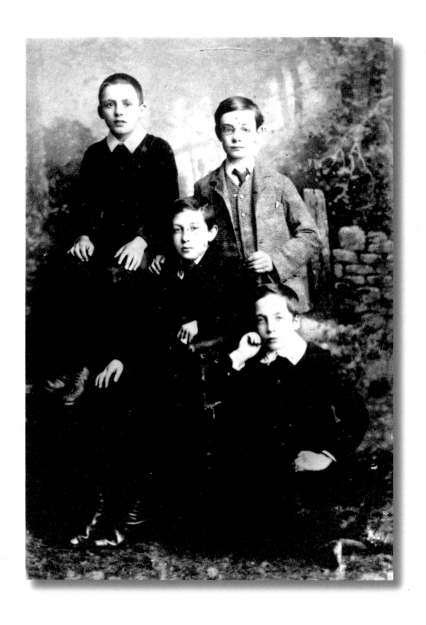

Pearse had his first formal introduction to the study of Irish in Westland Row. One of his teachers, Brother Justus Maunsell, was a native speaker from Kerry. He was transferred from the school in 1893 and this photo was taken on the occasion of his presentation with an illuminated address which was signed by Pearse (*standing*) and three of his schoolfellows, (*seated from left*) William Dwyer, George Quigley and Patrick Cooper. (Image courtesy of Kilmainham Gaol/OPW)

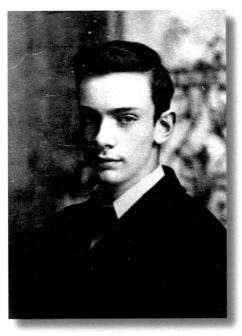

Pearse completed the Intermediate Examination aged sixteen. He was too young to attend university and so he became a pupil-teacher in Westland Row for two years.

He was a somewhat precocious teen and decided to set up a debating society with his school friend Éamonn O'Neill in December 1896 called the New Ireland Literary Society, which met weekly in the Star and Garter Hotel. Not surprisingly Pearse was elected president. (Image of Pearse courtesy of Kilmainham Gaol/OPW)

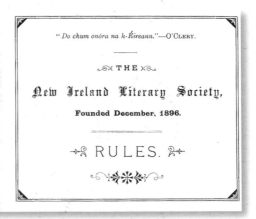

11. The subscription for membership shall be 1/6 per month, payable at the beginning of each month, or 10/- for the whole session, payable in two instalments.

12. Any member who absents himself for *three* consecutive meetings of the Society, without giving due notice to the Secretary, or who is seriously unpunctual in the payment of his subscription, is liable to have his name struck off the books of the Society.

13. If at any meeting of the Society there be less than ten members present, such meeting must adjourn or refrain from proceeding with the programme for the evening, until *at least ten members* are present.

14. Any member who wishes to have a rule changed must give at least a week's notice of the motion to that effect.

N.B.—The meetings of the Society are at present held in the STAR AND GARTER HOTEL, D'OLIER STREET, DUBLIN, and all communications should be addressed to the Secretary there:

" *Do chum onóra na h-Éireann.*"—O'CLERY.

THE
New Ireland Literary Society,
Founded December, 1896.

RULES.

RULES.

1. That this Society be called the "New Ireland Literary Society."

2. The object of the Society shall be the cultivation of literary and debating talents among the members, by means of lectures, debates, and the publication of original articles in a monthly magazine, to be established by the Society; and moreover, while not neglecting the discussion of subjects of world-wide importance, or of a general literary character, the Society's chief attention shall be devoted to the furthering of those interests and to the propagation of those ideas which are regarded as the main factors in the "New Ireland" movement, which is actively going on at the present day.

3. The Society shall be strictly non-political and non-sectarian, and all debates, lectures, etc., of a political or religious nature will be rigorously excluded.

4. There will be one session each year, lasting from the first week of September to the end of April.

5. The Society will hold its meetings on Tuesday evenings, at 7.30 p.m.

6. The order of procedure at the meetings will be:—

 A. *Business* consisting of (a) reading the minutes of the previous meeting; (b) reading correspondence; (c) election of members; (d) questions and motions; and (e) selection of debates, etc., which must be concluded at or before 8.15 p.m.

 B. The *Literary* portion of the programme.

7. The Society's Officers shall be a President, Vice-President, Auditor, Treasurer, Secretary, and Editor of the *M.S.* Journal.

8. The Officers shall be elected at the opening meeting of each session.

9. If an office become vacant through any cause whatsoever, it may be filled by an election at any ordinary meeting of the Society.

10. Any person wishing to become a member must be proposed by one member, seconded by another, and elected by ballot by the majority of the members present.

PROGRAMME.

PART I.

1. Overture : "Killarney". *Smith.*
 MISS M. PEARSE.

2. Vocal Solo : "The Risin' o' the Moon". *Casey.*
 MR. T. O'MOORE.

3. Vocal Solo : "An Cúlḟionn". *MacHale.*
 MR. W. ROONEY.

4. Violin Solo : "Le Rêve". *Goltermann.*
 MR. M. McKENNA.

5. Vocal Solo : "Juanita". ———
 MISS L. COMERFORD.

6. Recitation : "The Celtic Tongue". ———
 MR. E. O'NEILL.

7. Vocal Solo : "The Heart bow'd down". *Balfe*
 MR. T. MAHON.

8. Duet (Pianoforte) : "Mazurka des Traineaux". *Ascher·*
 MESSRS M. AND C. CURRAN.

9. Vocal Solo : "The Patriot Mother". *O'Doherty.*
 MR. P. MORGAN.

10. Recitation : "Mark Antony's Oration". *Shakespeare.*
 MR. P. H. PEARSE.

11. Vocal Solo : "Caṫ-Aḃna". *MacHale.*
 MR. P. BRADLEY.

PART II.

12. Duet : "Whispers from Erin". *Rockstro.*
 THE MISSES PEARSE.

13. Vocal Solo : "There is a charming girl I know". *Benedict.*
 MR. J. LAWLESS.

14. Violin Solo : Selections. ———
 MR. M. McKENNA.

15. Vocal Solo : "Yesterday". *Browne.*
 MISS L. COMERFORD.

16. Recitation : "The Death of Marmion" *Scott.*
 MR. J. MONKS.

17. Vocal Solo : "Hear me, gentle Maritana". *Wallace.*
 MR. T. MAHON.

18. Vocal Solo : "Óg-laoċ na Rann". *MacHale.*
 MR. T. O'MOORE.

19. Pianoforte Solo : "Selections from Faust". *Gounod.*
 MR. C. CURRAN.

20. Vocal Solo : "The Bard's Legacy". *Moore.*
 MR. J. MORAN.

21. The Ghost Scene from : "Hamlet". *Shakespeare.*
 Hamlet: MR. P. H. PEARSE. Marcellus: MR E O'NEILL.
 Horatio : MR. T. O'MOORE. Ghost : MR. P. BRADLEY.

22. Violin Solo : "As I view these scenes so charming". *Bellini.*
 MR. M. McKENNA.

23. Finale. "Let Erin Remember the Days of Old". *Moore.*

Accompanist : Miss M. B. Pearse.

The programme for the society's 'conversazione' on 6 April 1897 shows the heavy involvement of Pearse and his family in the activities of the society. Pearse performed Mark Antony's oration from *Julius Caesar,* as well as an extract from *Hamlet.* His sisters sang and Mary Brigid provided piano accompaniment.

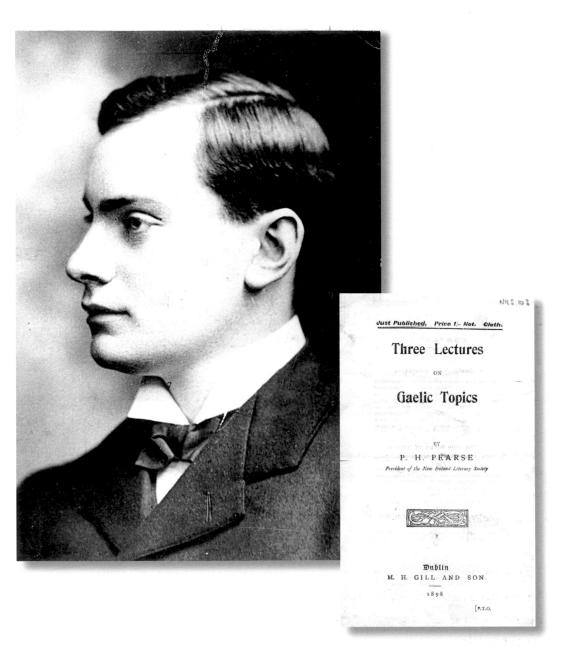

Aged just eighteen, Pearse published three of the lectures he delivered to the society under the title *Three Lectures on Gaelic Topics*. This image of Pearse was taken at age nineteen. (Image of Pearse courtesy of Kilmainham Gaol/ OPW)

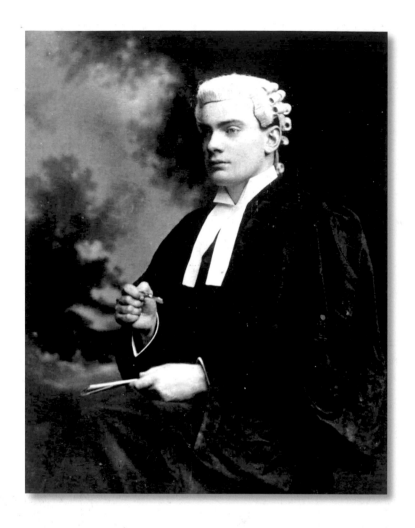

Pearse was awarded a BA in Modern Languages, which included English, Irish and French, from the Royal University in 1901. He was also studying Law at King's Inns and was called to the Bar in the same year.

Pearse never pursued a legal career, was often dismissive of the legal profession and affected to be ashamed of his association with it. However, he was also aware of the social caché it conferred on him, especially given his relatively humble origins. His practice of signing himself 'P. H. Pearse BA BL' was mocked by some of his rivals in the Gaelic League, who referred to him as 'B-A-B-L'.

Reference: Ruth Dudley Edwards, *Patrick Pearse: The Triumph of Failure*, p. 48

'AN FIOR GAEL': THE GAELIC LEAGUE

Pearse joined the newly established Gaelic League in 1896 and, despite his youth, rose quickly through its ranks. By 1898 he was a member of the Coiste Gnótha, the Executive Committee of the organisation, and headed up the Publications Committee.

In this photo he is pictured (*far left, second row from back*) at a meeting of the Representative Congress in Paris in 1900. Pearse's extremely formal costume of frock coat and top hat sets him apart from the other delegates and makes him appear somewhat priggish and overly concerned with the dignity of his position. According to Éamonn O'Neill, Pearse always dressed in this fashion at the Oireachtas, the Gaelic League's annual cultural festival. Other Gaelic Leaguers felt this show of respectability was inappropriate, presumably because it seemed too reminiscent of the British establishment, and they canvassed to remove him from the Executive Committee. Their opposition was withdrawn once it was explained to them by O'Neill and others that Pearse dressed this way as a mark of respect for the importance of the occasion.

Reference: Éamonn O'Neill, 'Patrick Pearse: some other memories', in *The Capuchin Annual*, 1935, p. 220

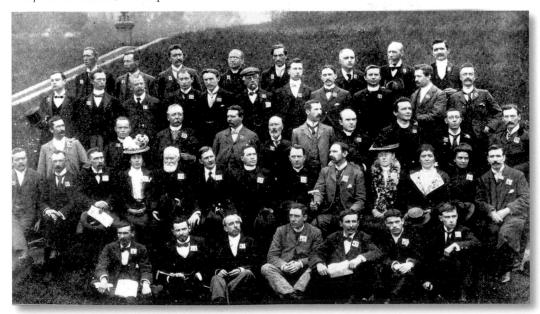

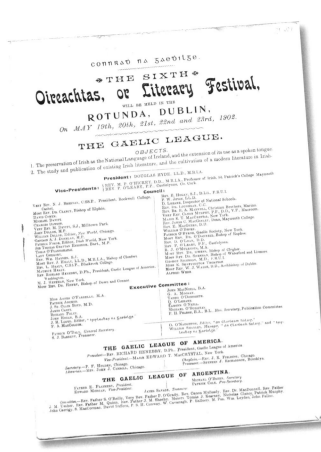

This programme for the Gaelic League's sixth Oireachtas, which was held in Dublin in 1902, lists Pearse among the members of the Executive Committee. He is also described as the Honorary Secretary of the Publications Committee.

The Gaelic League was founded in 1893 by Douglas Hyde, the son of a Protestant clergyman. Hyde had learned to speak Irish growing up in County Roscommon. He was a scholar and writer in Irish, publishing his works under the pseudonym 'An Craoibhín Aoibhinn' (the dear little branch). He was a figure of great stature among the Irish-language community and led the Gaelic League until 1915, when he resigned as a result of the increasing politicisation of the organisation.

Eoin MacNeill was one of the figures Pearse most admired in the language movement. He worked tirelessly for the language, as both a scholar and a teacher, becoming Professor of Old Irish in University College Dublin in 1908. According to Éamonn O'Neill, when Pearse heard of MacNeill's plans to marry his fiancée, Agnes Moore, in 1898, he almost wept with vexation, fearing 'it might lessen the activities of a man who was the light and inspiration of our work'. (The original image, LA30/PH/346, is held in UCD Archives, as part of the Tierney/MacNeill Photographs collection. The digital image was created by the Irish Virtual Research Library and Archive, and is reproduced by kind permission of UCD Archives and UCD Digital Library.)

Reference: Éamonn O'Neill, 'Patrick Pearse: some other memories', in *The Capuchin Annual*, 1935, p. 220

Pearse was an energetic and active member of the League and travelled the country speaking to local branches and officiating at Gaelic League events. He is pictured here on a Gaelic League excursion in 1907. (Image courtesy of the National Museum of Ireland)

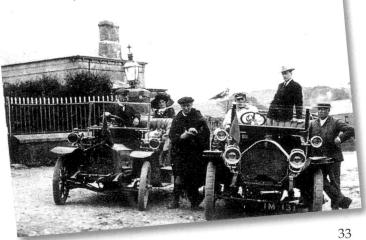

Despite his legal studies and involvement with the Gaelic League, Pearse still found time to assist in the family business. In 1900 Pearse and Sons were working on a pulpit for the Cathedral of St Eunan in Letterkenny, County Donegal. The 'Pulpit of the Four Masters' was to feature statues of four hereditary chroniclers of the O'Donnell clan from the seventeenth century. Between 1632 and 1636 they compiled a history of Ireland from ancient manuscripts which became known as the *Annals of the Four Masters*.

It would seem that Pearse's father asked him to research these historical characters and determine the correct costume to depict them in. One of the Four Masters, Mícheál Ó Cléirigh, was a Franciscan friar, so Pearse contacted Fr Thomas Anthony O'Reilly, the librarian in the Franciscan friary on Merchant's Quay in Dublin, seeking historical advice on the order's habit.

The pulpit was to be James Pearse's final significant commission, as he died before its completion. (Image courtesy of the National Library of Ireland)

Reference: Ignatius Fennessy, 'Patrick Pearse and the Four (or Five) Masters', in *The Donegal Annual/Bliainiris Dhún na nGall: Journal of the County Donegal Historical Society*, No. 53, 2001, pp. 81–7

James Pearse died in his home town of Birmingham on 5 September 1900 while visiting his brother. The image below of the Birmingham Museum and Art Gallery comes from James' set of magic lantern slides depicting views of the city. His business had done well in the years prior to his death and he had moved his family back to Sandymount, to 5 George's Ville. He left behind a substantial estate of £1470.17.6d. Following his father's death, Patrick and the rest of the family moved to a smaller house in nearby Lisreaghan Terrace, which Patrick renamed 'Liosán'. This piece of the family's stationery has a black border, probably indicating that they were still in mourning at the time.

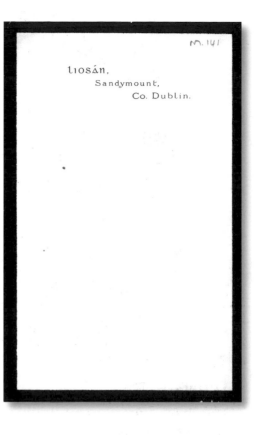

ʍ. 141

Liosán,
Sandymount,
Co. Dublin.

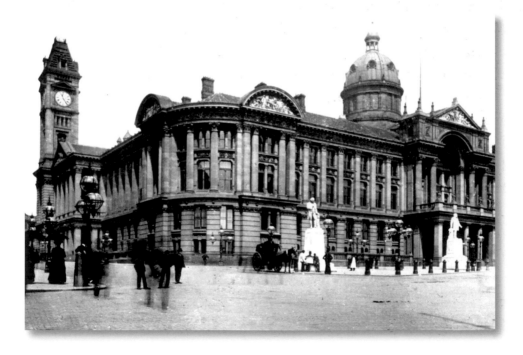

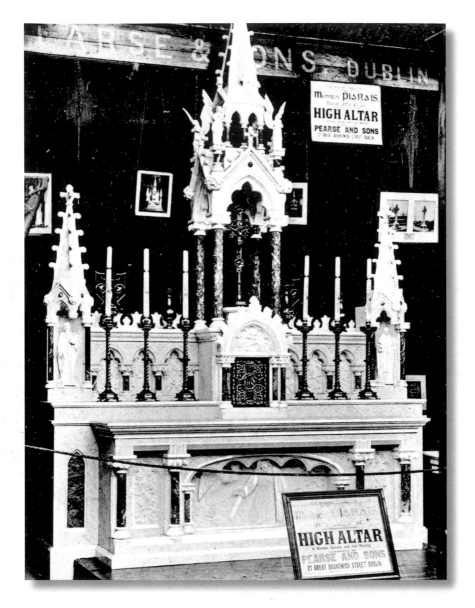

Patrick and Willie ran the business for nearly ten years after their father's death. They frequently advertised in the Irish-language press and emphasised their familiarity with the Irish language, Gaelic script and native imagery. The Irish version of the company name, 'Muintir MacPiarais', is displayed on this postcard showing the altar they submitted to the Cork International Exhibition in 1902. Although he was not involved in the creation of any of the work, Patrick would sometimes write the word 'sculptor' after his name by virtue of his role as one of the proprietors of the business.

Patrick was supportive of his brother Willie's artistic career and his studies in the Dublin Metropolitan School of Art (DMSA). Willie also attended classes in the School of Art in South Kensington, London, and made several study trips to Paris.

This statue of a boy was produced by Willie in the DMSA as an exam piece and significantly he signed his name 'Uilliam MacPiarais'.

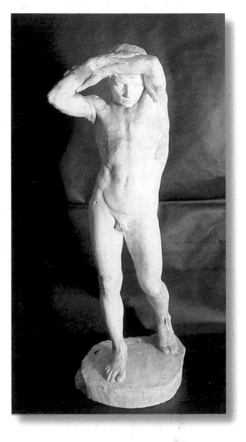

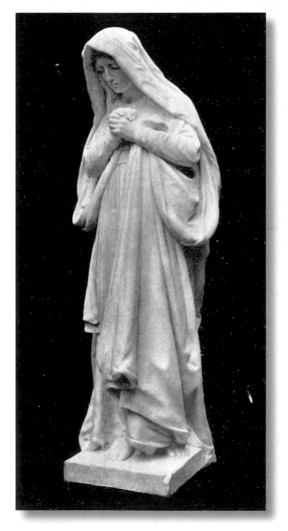

Willie also brought an artistic sensibility and individuality to his work at Pearse and Sons. Perhaps his finest commercial work was his statue of the Mater Dolorosa for St Andrew's Church on Westland Row.

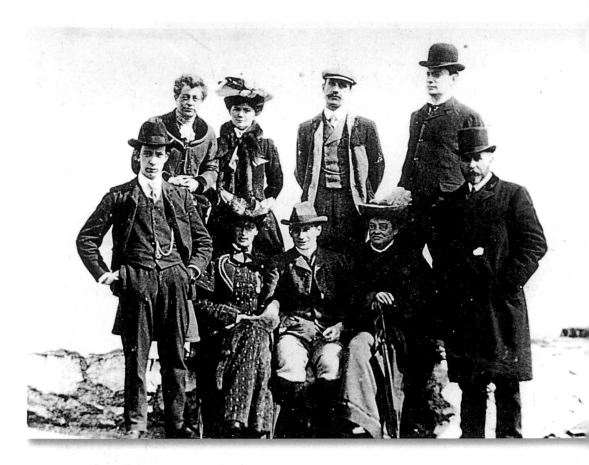

Willie shared his brother's enthusiasm for the Gaelic League and set up a branch in the Dublin Metropolitan School of Art. Above, he and Patrick can be seen at a Gaelic League event in Omeath, an Irish-speaking village in County Louth.

Back row (left to right): Professor Mary Hayden, Mrs Dora Sheridan (*née* Clayton), Edward (Ned) Sheridan, Patrick Pearse.
Front row: Willie Pearse, Eibhlín Niocaill (?), Harry Clifton, Mr and Mrs Geoghegan.

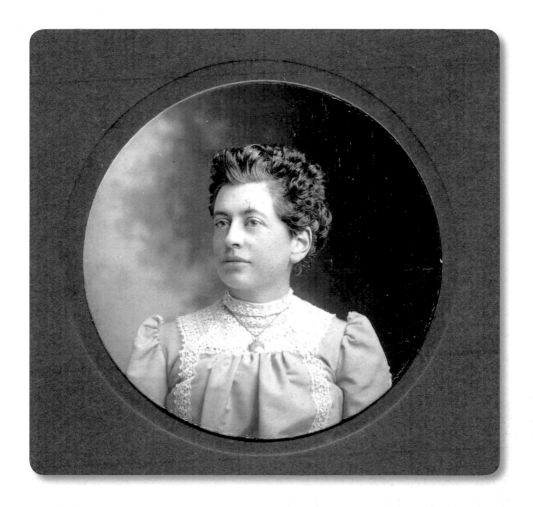

Mary Hayden was a prominent member of the Gaelic League and an early female pioneer in the Irish academic world. She and Pearse were good friends and in 1903 went on holiday to the Irish-speaking areas of Connemara. There was some disapproval of their holidaying alone and unchaperoned, but Mary dismissed this by pointing out that, as she was seventeen years his senior, Pearse could have been her son had she decided to marry early. She later remembered his concern about any cruelty to animals and the consternation he caused by stating that the English were superior to the Irish when it came to the treatment of animals.

References: Joyce Padbury, 'A Young Schoolmaster of Great Literary Talent: Mary Hayden's Friend, Patrick Pearse', in Roisín Higgins and Regina Uí Chollatáin (eds), *The Life and After-Life of Patrick Pearse*, p. 36; Mary Brigid Pearse (ed.), *The Home-Life of Pádraig Pearse*, p. 148

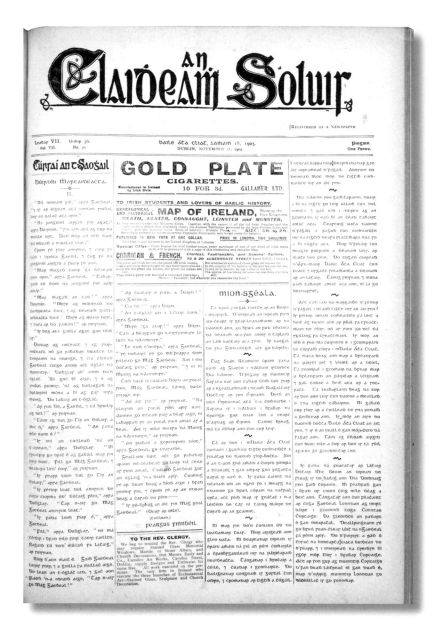

Pearse took over the editorship of the Gaelic League's newspaper, *An Claidheamh Soluis*, in 1903 at the age of twenty-three. As always, he approached the job with great energy, expanded its size and reinvigorated its content. He was not afraid to court controversy and criticised the Catholic Church's attitude to the Irish language on more than one occasion.

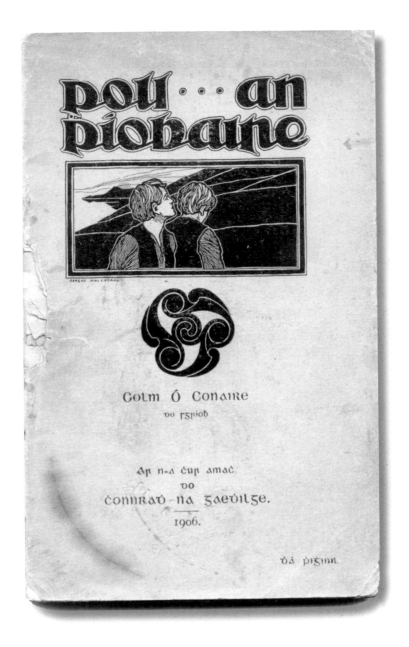

As editor of *An Claidheamh Soluis* and a former secretary of the Gaelic League Publications Committee, Pearse was aware of the lack of modern literature written in Irish. There was a large demand for Irish books from those wishing to learn the language. His own contribution was an adventure story for boys set in the West of Ireland entitled *Poll an Piobaire*, which he first published in *An Claidheamh Soluis* under the pseudonym Colm Ó Conaire in 1905. It appeared in book form the following year.

Pearse's next publication, *Íosagán agus Scéalta Eile*, was also set in Connemara. His aesthetic sensibility is evidenced in his decision to approach Sarah Purser, the artist and proprietor of the stained glass workshop An Túr Gloinne, to assist him in finding an illustrator for the book. It was she who introduced him to Beatrice Elvery, an artist who was working for her at the time. As Elvery didn't speak any Irish, Pearse had to come to the studio and translate the pieces he wanted illustrated. She described him as 'a bulky, pale, shy man whose black clothes made him look as if he belonged to some religious order'. Pictured are the front cover of the book and examples of Elvery's illustrations for the stories *Bairbre*, *An Sagart* (The Priest) and *Eoghainín na nÉan* (Eoineen of the Birds).

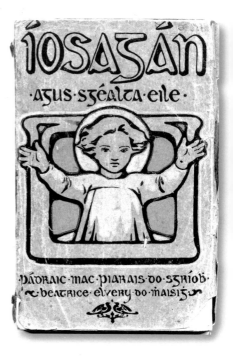

Reference: Beatrice, Lady Glenavey, *Today We Will Only Gossip*, pp. 90–1

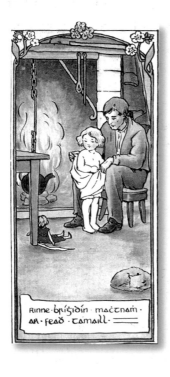

This photo shows Pearse officiating at a Gaelic League language event or Aeridheacht in Rosmuc in Connemara, a largely Irish-speaking area of County Galway, sometime around 1905. Connemara was where Pearse first went to connect with the Irish language and its native speakers. No other region of Ireland captured his imagination in the same way.

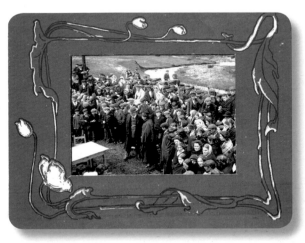

Pearse found inspiration amongst the people of Connemara and their stories greatly influenced his writings. He would sometimes arrange treats for the local children. On one occasion he brought his magic lantern with him and showed them exotic images from around the world, while on another he hired a man to put on a film show. The images below of St Mark's Basilica in Venice and the Arc de Triomphe du Carrousel were from Pearse's own collection.

References: Mary Brigid Pearse (ed.), *The Home-Life of Pádraig Pearse*, p. 144; Pádraic Óg Ó Conaire, 'Cuimhní Scoil Éanna', *Cuimhní na bPiarsach*, pp. 5–7

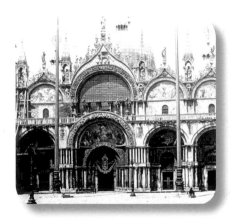
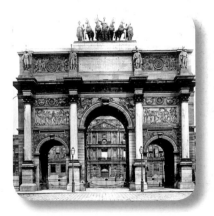

Pearse eventually purchased a small plot of land in Rosmuc and built himself a three-roomed cottage there. He built it facing north so he could always see the mountains when looking out the windows and doors. These images of Rosmuc and Pearse's cottage there were taken by a friend of the Pearse family called Alberta Glennon, who visited with Miss Margaret Pearse in the 1920s.

Pearse's interest in education stemmed from his growing belief that it held the key to the future of the Irish language. In 1905 he first visited Belgium to observe and write about their bilingual education system in a series of articles for *An Claidheamh Soluis*. He was very impressed with the way in which French and Flemish were taught together in Belgian schools and the use of modern teaching methods such as the 'Direct Method'. This system uses visual stimuli to teach students, and encourages them to learn through conversation and by using their language skills in everyday situations.

Pearse was accompanied on one of his trips to Belgium by his sister Margaret, who also spoke French. She later described how, when he wasn't carrying out his research, her brother took every opportunity to visit art galleries and historic buildings. He was also anxious to try out new things and visited a Chinese restaurant, but his sister refused to eat there. Feeling it was unpatriotic to spend too much money outside their own country, he advised her to buy only small souvenirs and works of art. Among the items they bought were a drawing of Bruges and a small framed photograph of Ostend.

Reference: Margaret Pearse, 'Patrick and Margaret Pearse' in *The Capuchin Annual*, 1943, pp. 87–8

SCOIL ÉANNA:
'AN EDUCATIONAL ADVENTURE'

In 1908 Pearse opened his own school and named it Scoil Éanna in honour of St Enda, the patron saint of the Aran Islands. The school was initially located in Cullenswood House, Oakley Road, between the Dublin suburbs of Ranelagh and Rathmines. It was an attractive Georgian house and had previously been the home of nineteenth-century historian W. E. H. Lecky.

In his prospectus for the school Pearse announced that it had been founded with the 'object of providing an elementary and secondary education distinctly Irish in complexion, bilingual in method, and of a high modern type generally, for Irish Catholic boys'. The pages shown are from that first prospectus.

Pearse managed to put together an impressive list of 'extern lecturers', including Douglas Hyde, W. B. Yeats and Padraic Colum. They showed their support for Pearse's project by agreeing to come and lecture the boys from time to time.

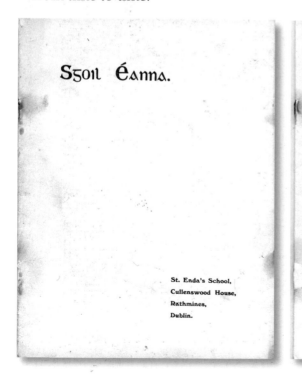

1. ᴀn ᵹeᴀᴛᴀ.—The Entrance Gate. 2. Cᴀpán Láiṙ ᴀn Uᴃᴀll-ᵹuiṙᴄ.—The Orchard Centre Walk. 3. ᴀn ṗáiṙc ᴀᵹuṡ Cúinne ᴅe'n Uᴃᴀll-ᵹoṙᴄ.—Field and Corner of Orchard from Schoolhouse.

Sᵹoil Éᴀnnᴀ: St. Enda's School, Cullenswood House, Rathmines, Dublin.

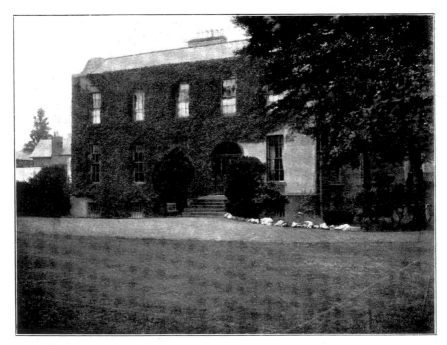

Ceᴀᴄ nᴀ Sᵹoile.—THE SCHOOLHOUSE.

Sᵹoil Éᴀnnᴀ: St. Enda's School, Cullenswood House, Rathmines, Dublin.

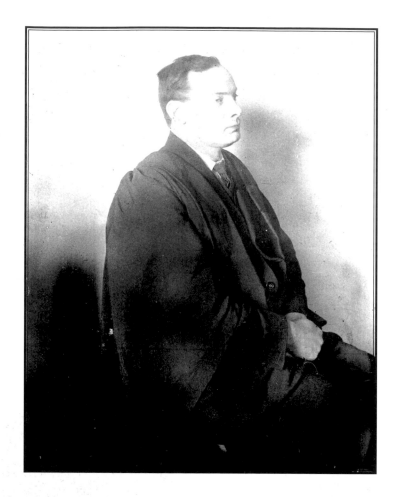

Pearse, who was often awkward and stiff in social situations, was at ease among his pupils and enjoyed being in their company. He passionately believed in the power of teachers to help children become their best selves:

> The true teacher will recognise in each of his pupils an individual human soul, distinct and different from every other human soul that has ever been fashioned by God, miles and miles apart from the soul that is nearest and most akin to it, craving, indeed, comradeship and sympathy and pity, needing also, it may be, discipline and guidance and a restraining hand, but imperiously demanding to be allowed to live its own life, to be allowed to bring itself to its own perfection; because for every soul there is a perfection meant for it alone, and which it alone is capable of attaining.

Reference: Patrick Pearse, *An Macaomh,* Christmas 1909, p. 13

Pearse wrote in the school prospectus about the care that had been taken with the decoration of the school and the 'carefully-considered scheme of colouring and design'. His aim was to encourage in the boys 'a love of comely surroundings and the formation of their taste in art. In the classrooms beautiful pictures, statuary, and plants replace the charts and other paraphernalia of the ordinary schoolroom.'

Pearse used many artworks from his family home to decorate the school. The Pearse family owned an impressive collection of sculpture casts and fine engravings which were used to adorn Scoil Éanna. Among them was this eighteenth-century engraving by the Irishman Luke Sullivan of *The March to Finchley* (1750) by William Hogarth. It depicts the mustering of the King's Guard at Tottenham Court Road in North London in 1745 in advance of their march north to face the forces of Bonnie Prince Charlie and his Jacobite army.

Reference: *Scoil Éanna Prospectus* 1908–9

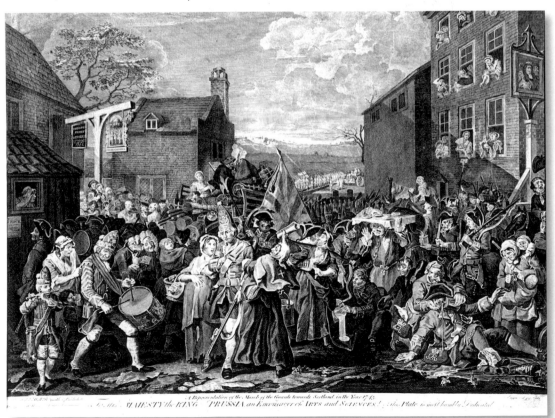

Patrick Pearse had a keen and informed interest in contemporary Irish art and wrote incisive reviews of art exhibitions for *An Claidheamh Soluis*. His brother Willie would have known many people in the Irish art world as a result of his attendance at the Dublin Metropolitan School of Art, and he also exhibited with a group of artists known as the Irish Art Companions. The school contained many works by contemporary artists, including Willie, whose sculptures were placed around the school as well as in the family's living quarters. Other leading Irish artists whose works were displayed included Jack B. Yeats, Æ (George Russell) and Beatrice Elvery. Sarah Purser donated some stained glass, now sadly lost.

'The Man who Buried Raftery' (1900) by Jack B. Yeats (*above*) was purchased by Pearse during his years as editor of *An Claidheamh Soluis* and hung in his study in the school.

This landscape was painted in 1909 by Count Casimir Dunin-Markievicz, husband of the 1916 rebel Countess Constance Markievicz. An ethnic Pole from a noble Ukranian family, Casimir met his Anglo-Irish wife, Constance Gore-Booth, while studying art in Paris. They moved to Dublin after their marriage and Casimir sought to establish himself as an artist. They became well-known figures in Irish cultural circles and were regular supporters of Scoil Éanna.

Pearse hung this depiction of Íosagán, which was painted by Beatrice Elvery, in the entrance hall of Cullenswood House. When the school moved to Rathfarnham in 1910 it was once again prominently displayed in the front entrance. The painting depicts Christ as a young boy against the backdrop of an Irish rural landscape. His arms are outstretched in a premonition of his crucifixion. The figure depicted would have been a similar age to the boys in Scoil Éanna and this painting was intended to portray an ideal for them to live up to.

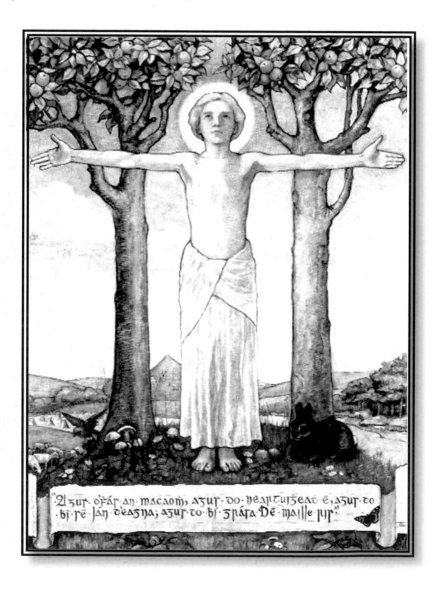

Éire (or *Éire Óg* as it was also known) by Beatrice Elvery was inspired by W. B. Yeats and Lady Gregory's one-act play, *Cathleen Ní Houlihan*. It was purchased for Scoil Éanna by Maud Gonne.

Years later a former pupil of the school told Beatrice Elvery that the picture had inspired him to try to die for Ireland. She expressed her shock that her 'picture might, like Helen's face, launch ships and burn towers!' (Image courtesy of Lady Davis-Goff)

Reference: Beatrice, Lady Glenavey, *Today We Will Only Gossip*, p. 91

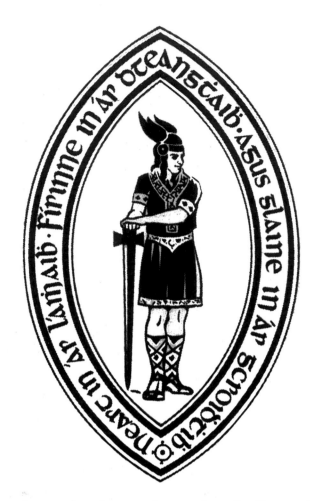

The school crest featured an image of an ancient Gaelic warrior surrounded by the motto 'strength in our limbs, truth on our lips and purity in our hearts'.

Pearse hired the set designers Edwin and Jack Morrow to paint elaborate friezes and murals on the internal walls of the school. Pictured here are the remains of the motto they painted above the doorway of Cullenswood House. The quote is taken from words attributed to Cúchulainn, the hero of the ancient Irish hero saga, *An Táin*: 'I care not if I live but one day and one night provided my fame and my deeds live after me.'

The school quickly developed a reputation for the quality and the innovation of its theatrical performances. On 22 March 1909 the boys performed *An Naomh ar Iarraidh* (The Lost Saint) by Douglas Hyde, pictured here. It took place in the theatre of Cullenswood House, a small, corrugated-iron structure in the grounds, where a stage and proscenium arch had been erected. It was performed as part of a double bill with *The Coming of Fionn* by Standish O'Grady.

Among the audience were the writer and academic Stephen Gwynn, Edward Martyn, Padraic Colum, Eoin MacNeill, Mary Hayden, Mr and Mrs Don Piatt, Count and Countess Markievicz, Agnes O'Farrelly, Sir John Rhys, W. B. Yeats and Standish O'Grady, who was accompanied by his wife.

Hyde's play was put on a second time, in the Abbey Theatre on 9 April 1910. The diarist Joseph Holloway, who had been enthusiastic in his praise for the original production, felt the translation to the Abbey stage was a complete success, though he did note that 'most of the boys seemed to have outgrown their tunics & long stretches of bared limbs were the rule & not the exception'.

Reference: Holloway Papers, National Library of Ireland

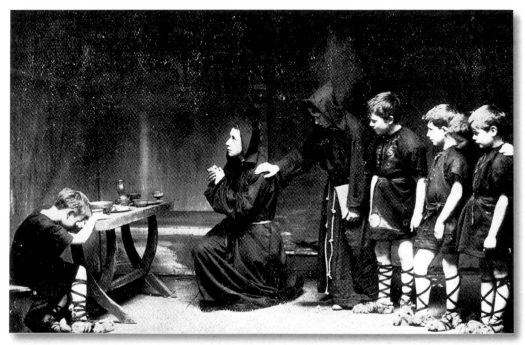

Standish O'Grady not only attended the performance of his play, *The Coming of Fionn*, in Cullenswood House, he also gave an impromptu speech afterwards in which he called for a return to the values and simplicity of ancient Ireland. The lead role of Fionn was played by Denis Gwynn, the son of the MP and writer Stephen Gwynn. Denis was a talented actor and a brilliant student. He won the first of the Classical Scholarships in the entrance exams for University College Dublin in 1910. He seems to have been a particular favourite of Pearse, but came to disagree with him politically as he grew older, and fought with the British Army during the First World War.

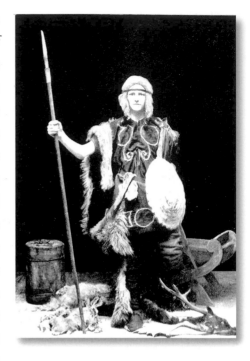

Playing opposite Denis Gwynn, in the role of Cairbre, was Eamonn Bulfin. Eamonn was born in Argentina, where his father, William, ran a Buenos Aires-based newspaper called *The Southern Cross* which served the Irish-Argentinian community. He was also the author of the very popular travelogue *Rambles in Erin*. Eamonn later fought in the 1916 Rising and during the War of Independence he was appointed as Irish representative to Argentina by Éamon de Valera.

The heroes of the ancient Irish sagas, such as Fionn Mac Cumhail and Cúchulainn, were presented as role models to the boys of Scoil Éanna. Pearse saw the school as being in the tradition of the ancient boy-corps of Eamhain Macha, in which the young Cúchulainn had been raised and educated. In that tradition children were brought together 'in some pleasant place under the fosterage of some man famous among his people for his greatness of heart, for his wisdom, for his skill in some gracious craft'. A former pupil from Scoil Éanna remarked that Cúchulainn was mentioned so often in the school it was as if he was 'an important but invisible member of staff'!

These images of Cúchulainn were drawn in the 1920s by Patrick Tuohy, a former pupil of Scoil Éanna, for an edition of Standish O'Grady's novels *The Coming of Cuchulain* and *In the Gates of the North*, published by The Talbot Press.

References: Patrick Pearse, *An Macaomh*, Christmas 1909, p. 13; Desmond Ryan, *The Story of a Success: being a Record of St. Enda's College September 1908 to Easter 1916*, p. 90

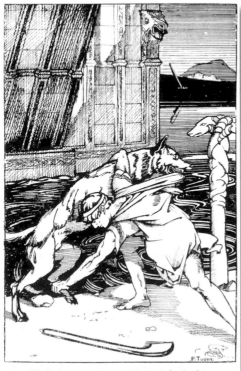

"If the boy comes now, ere I can chain the dog, verily he will be torn into small pieces."

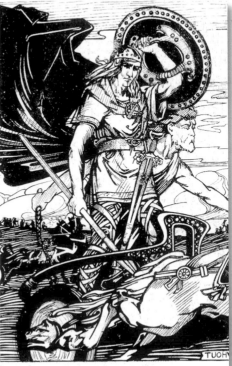

"The noble steeds flew along nor needed at all the scourge of the charioteer."

In 1909 Pearse wrote an elaborate pageant entitled *Mac-Ghniomharta Cúchulainn* (The Boy-deeds of Cúchulainn). Frank Dowling, who played the title role, is photographed here in his costume. Joseph Holloway attended this open-air production on 22 June 1909 in the grounds of the school. Despite a heavy shower of rain before it started, he felt it passed off well. Among the audience was the sculptor Oliver Sheppard, Eoin MacNeill, Edward Martyn, Ella Young and Countess Markievicz.

Sourcing appropriate textbooks and teaching in Irish was a big challenge for Pearse and other Irish-language educators. Pearse proposed producing his own series of textbooks in Irish. In 1913 he published a series of sample Irish lessons he had written for *An Claidheamh Soluis* between 1907 and 1909 under the title *An Scoil*.

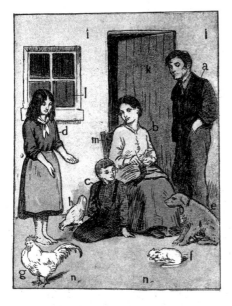

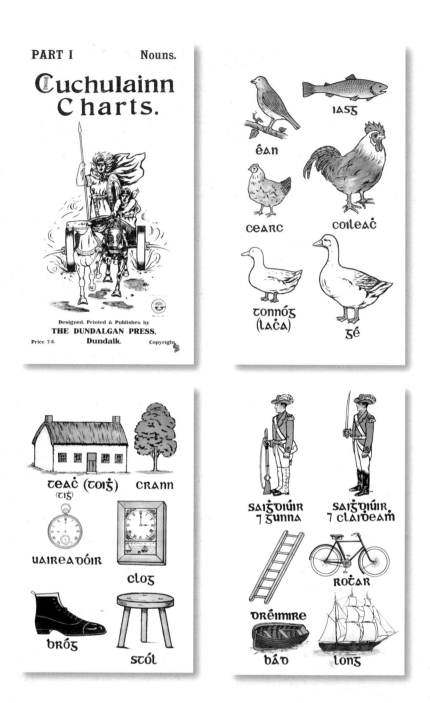

Pearse used the *Cuchulainn Charts* and textbook produced by The Dundalgan Press as an aid to teaching Irish in the school. They were designed to be used as part of *An Modh Direach* or the 'Direct Method' system which Pearse had earlier seen used in Belgian schools.

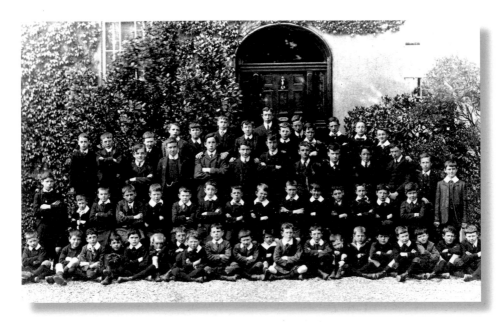

This school photograph was taken near the end of the first school year in May 1909.

Thomas MacDonagh was among the first teachers in Scoil Éanna and served as assistant headmaster. He had previously taught English, History and French in St Kieran's College, Kilkenny, and St Colman's in Fermoy. He was an active member of the Gaelic League and supportive of Pearse's project in Scoil Éanna. Pearse and MacDonagh were both idealists, were close in age and shared a love of literature and the theatre. However, they had very different personalities. MacDonagh was light-hearted, easygoing and full of fun, in contrast to the sombre, serious and socially awkward Pearse. Despite these differences they became close friends and MacDonagh played a central role in the school and its activities. (Image courtesy of Kilmainham Gaol/OPW)

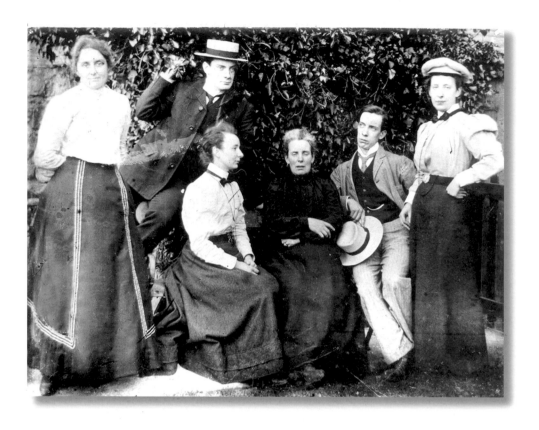

Left to right: Miss Brady (a cousin), Patrick Pearse, Miss Margaret Pearse, Mrs Pearse, Willie Pearse, Mary Brigid Pearse.

The involvement of his family was a key part of Pearse's vision for Scoil Éanna. Willie taught art and was to become Pearse's deputy in all but name. Mary Brigid taught music and Margaret was an assistant mistress. His mother acted as housekeeper. Pearse stated that the school was a return to the Gaelic tradition of fosterage, where a young boy would be raised and taught by a neighbouring clan. A former pupil, Kenneth Reddin, remarked upon the un-institutional feeling of the school, which he attributed to the fact that women were in charge of the domestic arrangements. Pearse emphasised his mother and sisters' involvement in the prospectus, suggesting that this 'in conjunction with its private character renders the school specially suited for the education of sensitive and delicate boys'.

Reference: Kenneth Reddin, 'A Man Called Pearse', in *Studies*, June 1943, pp. 241–51

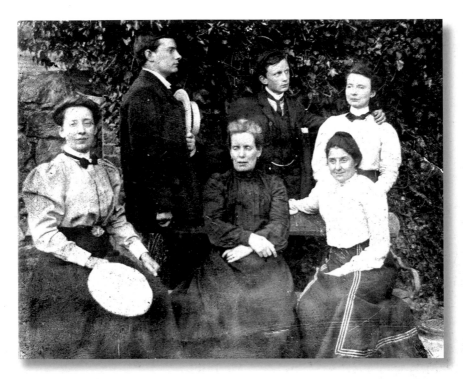

Standing (left to right): Patrick Pearse, Alfred McGloughlin, Miss Margaret Pearse. *Seated:* Mary Brigid Pearse, Mrs Pearse and Miss Brady.

This photograph was taken on the same occasion as the previous image, but Willie Pearse has swapped places with Alfred McGloughlin. Alfred was the son of Pearse's half-sister Emily, and was very close to the Pearses. He was also involved in the running of the school, in particular the school theatricals. Note also that Pearse has adopted his customary side-profile in this picture. (Image courtesy of Kilmainham Gaol/OPW)

This is a rare image of Pearse looking at the camera face on. He was very self-conscious of having a 'squint' in one of his eyes. It appears to have affected him from birth and was hereditary. Whenever possible he made sure that he was only photographed in side-profile.

Willie, Mary Brigid and Alfred McGloughlin shared Patrick's love of the theatre and formed their own theatre company in 1910 called the Leinster Stage Society. This programme, which features a drawing of an ancient Irish hero by Willie, was from a performance in the Abbey Theatre on 27 May 1910. Two of the plays were written by Mary Brigid and one was by Alfred. Willie was a keen actor and played many of the leading roles.

The Pearses hoped the Leinster Stage Society would bring in extra revenue for the family and school. However, they disbanded the society following a disastrous trip to Cork city in 1912, when they had to write to Patrick for money to clear their debts and get themselves home.

Programme.
Friday, May, 27th, 1910,
at 8.15.

Abbey Theatre.

The Message:
A Play in One Act and an Epilogue.
BY M. B. PEARSE.

Donal	-	WILLIAM PEARSE.
Shaun	-	FRED HOLDEN.
Tadhg.	-	MORGAN O'FRIEL.
A Neighbour	-	J. DORAN.
Maire	-	MISS JULIE HAYDEN.
Noreen	-	MAUREEN NUGENT.
Cathleen	-	MISS ELLA DELANEY.
Lady Rivers	-	MISS M. ANDERSON.
Mona Fitzgerald	-	MISS MARY FITZGERALD.

SCENE :—Maire's Kitchen.
Evening.—The Departure of the Swallows.
EPILOGUE :
Following Year.—The Return of the Swallows.

The Countess of Strasbourg:
An Incident of 1805
BY A. McGLOUGHLIN.

Napoleon	-	WILLIAM PEARSE.
Marshal Ney	-	EAMONN BULFIN.
General Klenau (of the Austrian Army)		SORLEY MACGARVEY.
Pierre (an Innkeeper)	-	FRED. A. McDONALD.
Captain Bernard	-	RICHARD BOYD.
Mdlle. Renée Mayenne (a Vivandière)		MISS MARY FITZGERALD.

SCENE :—Interior of an Inn on the outskirts of Ulm.
Time.—Evening, October 5th, 1805.
"The close of the Austrian Campaign witnessed the advance of a very capable man." *Bourrienne's Memoirs of Napoleon.*

Over the Stile:
A Play in Two Scenes.
BY M. B. PEARSE.

Pat Casey	-	FRED. A. McDONALD.
Barney O'Brien / Alec, a Scotchman } Field hands {		WILLIAM PEARSE. / MORGAN O'FRIEL.
Mrs. Casey	-	MISS JULIE HAYDEN.
Katie	-	MISS ELLEN DELANEY.
Peggy	-	MISS MARY FITZGERALD.

SCENE I.—Exterior of Pat Casey's Cottage.
By the Stile.—Sunset.
SCENE II.—Over the Stile—At the Well.
Next Evening.

The Transformation of Fionn,
BY STANDISH O'GRADY.

Fionn	-	WILLIAM PEARSE.
Nod	-	RICHARD BOYD.
Ossian	-	MORGAN O'FRIEL.
Fairy	-	MISS MARY FITZGERALD.

Warriors and Gillies :—EAMONN BULFIN, SORLEY MACGARVEY, FRED. HOLDEN, TADHG. CARLETON.

SCENE :—By the Lake on Slieve Gullion.
Original Music by Tomás MacDonnaill.

During the Intervals the String Orchestra will play :—
1.	Irish Airs	-	Volti.
2.	Tannhauser	-	Wagner.
3.		Selected.	
4.	Gavotte	Selected.	

ANTIQUES LENT BY MESSRS. WALSH.

NEXT WEEK
Dublin Art Students' Union in Five Plays.

64

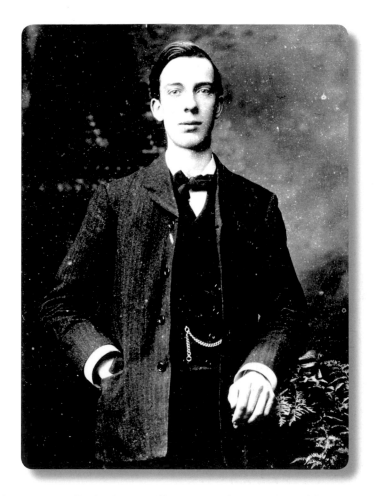

Desmond Ryan recalled when Willie Pearse first took up his post as Drawing master at the school:

> He gave us, with his quiet, nervous manner, his flowing tie, his long hair brushed back from his forehead in an abundant curve, the impression of an artist first and last, that expression excellently conveyed in several of the full-length portraits of him now common. As a teacher he was most painstaking. He acted consistently upon his brother's maxim that the office of any teacher is to foster the characters of his pupils, to guide them rather than to repress them, to bring to fruition whatever glimmerings of ideals and goodness they possessed rather than to indoctrinate them with their master's prejudices or drive them through a course of studies like so many little tin soldiers.

Reference: Desmond Ryan, *A Man Called Pearse*, p. 198

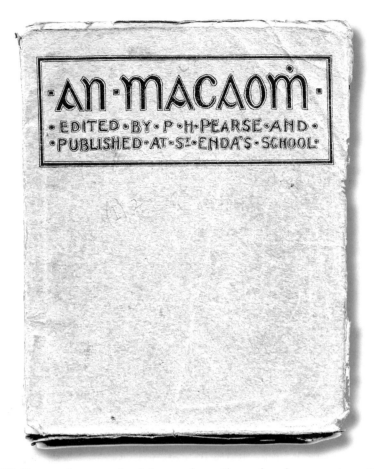

In June 1909 Pearse began *An Macaomh* as the school magazine. The title came from the name used in ancient Gaelic society for boys who were sent to neighbouring clans to be educated and taught the skills of warfare. He intended it as a 'genuine Review, educational and literary, rather than a glorified Prospectus, but that it will be a personal mouthpiece in a sense that is quite uncommon among kindred publications'. Some of the teachers and extern lecturers, such as Thomas MacDonagh and Padraic Colum, contributed items, as did boys like Denis Gwynn and Eamonn Bulfin. The magazine was illustrated with images of artworks from the school collection, including works by Æ (George Russell), Willie Pearse, Beatrice Elvery and Jack B. Yeats.

Only four editions of *An Macaomh* appeared, the last being published in May 1913.

Reference: Patrick Pearse, *An Macaomh*, Midsummer 1909, p. 7

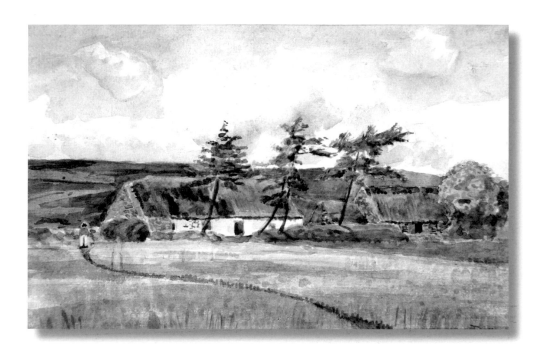

The artist Patrick Tuohy was a pupil in the school until 1910. The Pearse brothers spotted his talent, and his painting 'In County Wicklow' was published in the Christmas 1909 edition of *An Macaomh*. He also produced two sets of caricatures of students and teachers for the magazine. Tuohy went on to become a significant Irish portraitist of the 1920s and 1930s.

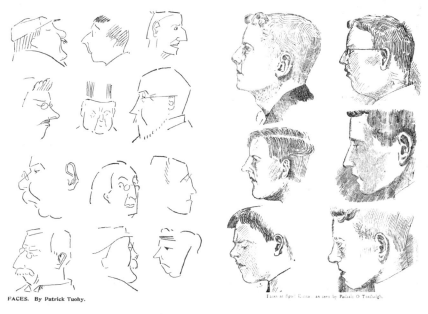

FACES. By Patrick Tuohy.

Faces at Sgoil Éanna : as seen by Pádraic Ó Tuathaigh.

Writing in *An Macaomh* in December 1909, Pearse spoke about his pleasure at the success of the school's athletic teams:

> Our boys must now be amongst the best hurlers and footballers in Ireland. Wellington is credited with the dictum that the battle of Waterloo was won on the playing fields of Eton. I am certain that when it comes to a question of Ireland winning battles, her main reliance must be on her hurlers. To your camáns, O boys of Banba!

The images below and opposite (*top*) show the junior football team, holders of the Dublin Schools Cup in 1910–11, and the Scoil Éanna hurling team of 1909–10 respectively.

Reference: Patrick Pearse, *An Macaomh*, Christmas 1909, p. 17

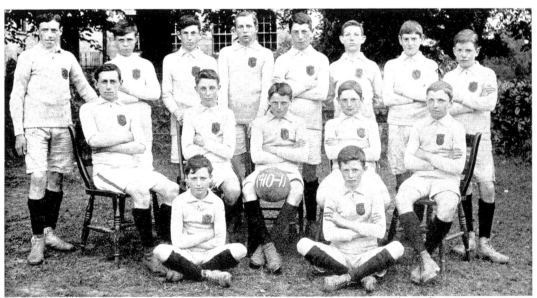

Sgoil Éanna, Ráṫ Feaṁnáin : Peileaḋóiṙí (Sóiṡiṙ), Luċt Buaiḋte Cuṗaḋ-ṁiṙ Baile Áṫa Cliaṫ, 1910-11.
St. Enda's College, Rathfarnham : Junior Football Team, Holders of Dublin Schools Cup, 1910-11.
P. Breaṫnaċ, R. Mac Aṁlaoiḃ, D. Ó Tuaṫail, S. Mac Diaṙmada, S. Ó Dúnlaing, P. Ó Maolṁuaiḋ, C. Mac Fionnlaoiċ,
F. Ó Doċaṙtaiġ, S. Ó Duḃġaill, D. Seoiġe, F. de Búṙca (Taoiṡeaċ), U. Ó Cúlaċáin, D. Ó Cléiṙiġ,
C. Ó Cléiṙiġ, S. Ó Conċoḃaiṙ.

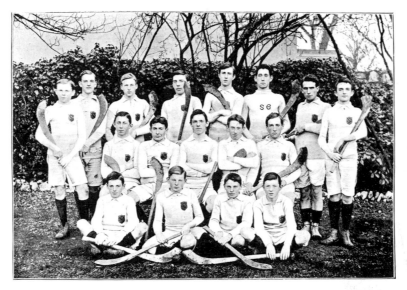

M. Caoṁánać, D. Ó Concubaiṙ, S. Mac Ġarbaiġ, U. Ó Doċarταiġ, C. Buiłfin, P. Ó Conaiṙe, S. Ó Faoḋaġáin. U. Mac Suiḃne.
S. Mac Διαρṁαδα, A. Ó Ġoinín, M. Ó Feaṙaċáiṙ (Ceann Feaḋṁa), P. Ó Conġaiłe, P. Ó Duḃḟláine.
F. Ó Doċarταiġ, D. Ó Cṙónín, P. De Búṙca, C. Mac Ḋaiḃeáċ.

Pearse's vision for Scoil Éanna was that it would become a 'Boy Republic' in which the boys were given a large degree of autonomy to manage their own affairs provided they did so in an honourable and fair way. The boys elected school officers from amongst their own number and were involved in many important decisions about the running of the school.

In 1913 the boys arranged a debate on whether they would play cricket. A vote was taken and the decision made to play

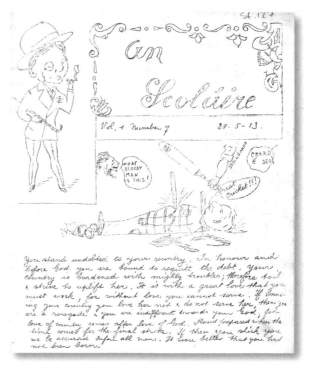

only Irish games. The banning of cricket is reflected in a cartoon produced in the boys' own in-house magazine, *An Scoláire*. It shows a cricket player staked through the chest by a cricket stump.

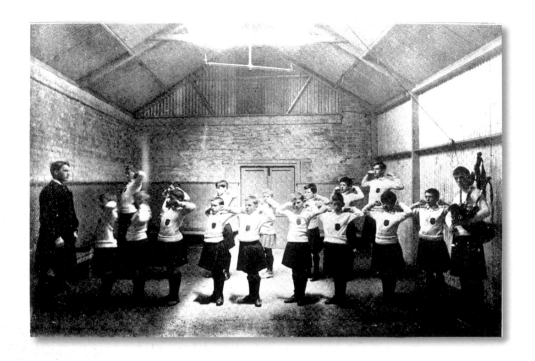

Drill and physical education played a central role in the school's curriculum. The boys in this picture wear kilts, an optional school uniform which, according to the school prospectus, provided 'an economical, hygienic, and becoming costume for boys'.

This satirical cartoon by Patrick Tuohy pokes gentle fun at the prospect of a rifle range being installed in Scoil Éanna and the idea of the bookish Pearse and MacDonagh learning to shoot. (Image courtesy of the Board of Trinity College Dublin)

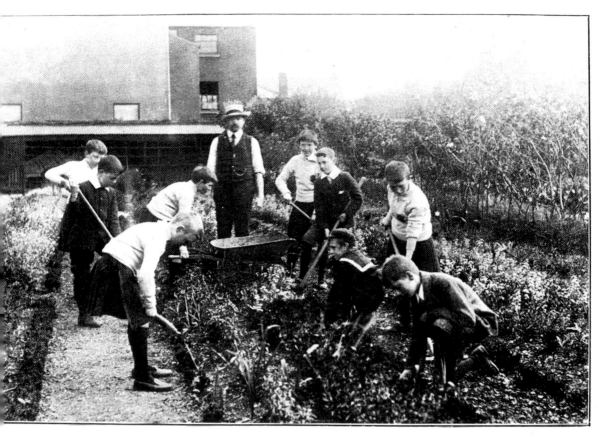

ᵉᵃⁿ ᵃₛ ᵽoᵹᴸᴀım Ᵹᴀᵽᵽᴜ́ᴀᴅᴏ́ıᵽᴇᴀᴄᴛᴀ ᵽᴀ́ ᵯ�archᴇᴀ́ᴸ ᵯᴀₛ ᴋᴜᴀıᵱᵽı : In the School Garden—A Gardening Class at Work.

The school prospectus also makes mention of the fact that any pupil who desired it would be 'allotted a plot of ground, which he is at liberty to plan out and cultivate according to his own taste, but under skilled direction'. Horticulture classes were given by Mícheál Mac Ruaidhrí, a native Irish speaker from Mayo. He was also a prize-winning Irish-language storyteller.

Reference: *Scoil Éanna Prospectus* 1908–9

Padraic Óg Ó Conaire was a native speaker from Rosmuc in Connemara, where Pearse had his holiday cottage. He was one of several native-Irish-speaking boys who were given the opportunity to attend Scoil Éanna.

This photograph of Pearse and his brother is said to have been taken in the grounds of The Hermitage in Rathfarnham shortly after he moved Scoil Éanna there in 1910. The Hermitage was a large, granite, eighteenth-century villa surrounded by fifty acres of parkland. While Cullenswood House was 'beautiful and roomy', it was 'too much in the Suburban Groove'. Rathfarnham, on the other hand, was at that time at the very edge of the city, in the foothills of the Dublin Mountains.

Reference: Patrick Pearse, *An Macaomh*, Christmas 1910, p. 9

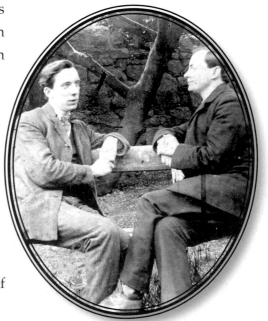

Pearse described how he had happened upon The Hermitage in *An Macaomh* in 1910. He had been reading Stephen Gwynn's biography of the nineteenth-century rebel Robert Emmet and was seized with a desire to visit places associated with him. Emmet's great love, Sarah Curran, lived across the road from The Hermitage in a house called The Priory. Her father, the celebrated jurist John Philpot Curran, disapproved of the match, so the young lovers would meet secretly in the grounds of The Hermitage, presumably with the connivance of its owner, Edward Hudson.

The story of Robert Emmet and his rebellion of 1803 had always fascinated Pearse. Emmet's youth, idealism and the dramatic nature of his trial and execution appealed to Pearse's romantic sensibility. His obsession with Emmet grew following his move to The Hermitage. Speaking in the United States some years later, he said that the house and grounds were 'very full of heroic memories'. He found it 'easy to imagine his [Emmet's] figure coming out along the Harold's Cross Road to Rathfarnham, tapping the ground with his cane, as they say was his habit; a young, slight figure, with how noble a head bent a little upon the breast, with how high a heroism sleeping underneath that quietness and gravity!' Many features in grounds of The Hermitage became associated with him, including a path known as Emmet's Walk, and Emmet's Fort (*below*), a miniature lodge built in imitation of a five-pointed, star-shaped military fort.

Reference: Patrick Pearse, 'How Does She Stand?: Robert Emmet and the Ireland of To-day', in *The Complete Works of P.H. Pearse: Political Writings and Speeches*, pp. 67–8

The Hermitage was built in the 1780s by Edward Hudson, a prominent Dublin dentist. He named it 'The Hermitage' to suggest it was a retreat, a place of contemplation where one could escape the cares of the city. The hermitage theme was further enhanced by placing a series of garden follies throughout the landscape, which included a hermit's cave and mock-ecclesiastical ruins. Both Edward Hudson and his son, William Elliot, were amateur antiquarians. Their interest in Ireland's past may have influenced the inclusion of other follies in imitation of ancient Irish monuments, such as a mock ogham stone and dolmen.

William Elliot Hudson was a member of the Celtic and Ossianic Societies and Pearse noted that on his death he endowed the Royal Irish Academy with funds for the publication of an Irish dictionary.

Combined with the surrounding park's dramatic landscape of wild mountain streams and natural rocky outcrops, the Hudsons had created the kind of picturesque scene which appealed to Pearse's romantic nature.

Sgoil Éanna, Ráṫ Ḟearnáin: An tEas.
St. Enda's College, Rathfarnham: The Waterfall.

In describing the eighteenth-century homes of Hudson and his contemporaries, Pearse wrote:

> An aroma as of high courtesy and rich living, sometimes passing into the riotous, still adheres to them. The Bossi mantelpieces, the great spaces of hall, the old gardens with their fountains and sun-dials, carefully walled in from the wilderness, all this has a certain homely stateliness, a certain artificiality if you will, not very Irish, yet expressive of a very definite phase in Irish, or Anglo-Irish, history.

Reference: Patrick Pearse, *An Macaomh*, Christmas 1910, p. 13

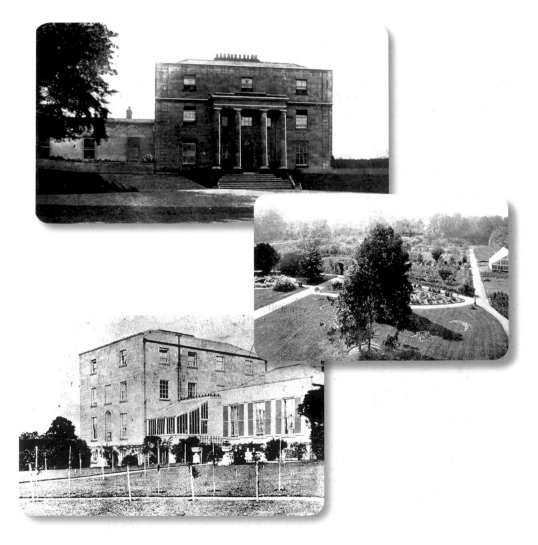

SGOIL EANNA: An Old Bridge
on the Stream (drawn by Alfred
McGloughlin.

SGOIL EANNA: The Grave
of Sarah Curran's Horse.
(drawn by Alfred McGloughlin.)

Alfred McGloughlin provided a number of drawings of features in the grounds of The Hermitage for the first edition of *An Macaomh* following the move there in 1910. Among his drawings was one of an obelisk which was said to be a memorial to Sarah Curran's horse. In fact it seems that the obelisk was of a much later date and was erected by a member of the Kavanagh-Doyne family who owned the house in the mid-nineteenth century.

SGOIL EANNA: Where the River comes in
(drawn by Alfred McGloughlin).

The Whitechurch stream which flowed through the grounds of The Hermitage was dammed to form a lake, before flowing over a series of cascades and rills. The gardener who showed Pearse around when he first viewed the grounds remarked, ''Tis wonderful the life a bit of water gives to a place.'

When it was in full flow, Pearse could hear the roar of the water from his bedroom: 'It reminds me of the life out there in the woods, in the grass, in the river.' He would imagine the wildlife in the park, like the happy, innocent rabbits and the river rats and otters who preyed upon them. The cycle of life and death in the natural world fascinated him and he wrote that 'day and night there is red murder in the greenwood'. While Pearse was well-known for his horror of any suffering inflicted on animals, he accepted this as the natural way of things and observed that 'Life springs from death, life lives on death'. This was a theme and a phrase he would return to in his oration at the grave of O'Donovan Rossa in 1915.

Reference: Patrick Pearse, *An Macaomh*, Christmas 1910, p. 9

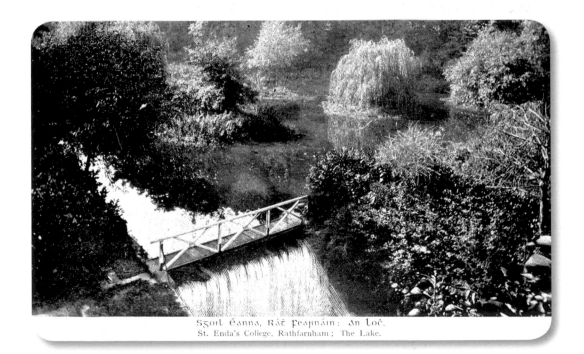

Sgoil Éanna, Rát Peannáin: An Loc.
St. Enda's College, Rathfarnham : The Lake.

In addition to playing fields, the school contained a handball alley, tennis courts and a bicycle track. Plans for a swimming pool were never realised, but the boys did swim in the stream, as seen in this picture.

Pearse spoke about the 'physical hardening which would result from the daily adventure face to face with elemental Life and Force, with its moral discipline, with its physical hardening, which ought to play so large a part in the education of a boy'.

Reference: Patrick Pearse, *An Macaomh*, Christmas 1910, pp. 14–15

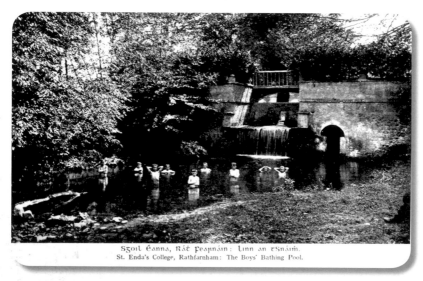

Sgoil Éanna, Ráṫ Feaṗnáin: Linn an tSnáṁ.
St. Enda's College, Rathfarnham: The Boys' Bathing Pool.

Sgoil Éanna, Ráṫ Feaṗnáin: Paiṫċe na hImeaṗṫa.
St. Enda's College, Rathfarnham: The Playing Field.

The Hermitage offered much-improved facilities for the school over Cullenswood House, including the Study Hall or 'Halla Mór'. It contained a large fireplace which attracted pupils on cold nights, as described in this account by former pupil Kenneth Reddin:

I thought of the big fire in the Study Hall. I peered in, shivering. In the dark I heard a thread of sound, the low music of a voice uttering itself in confidence. My ear directed me to the recess where a huge log fire was burning. Clear, soft, eager, the Headmaster's voice recounting a story of Finn and Oscar and Ossian. On the tale went, on … I tried to escape, but bungled into something.

'Cé tá ansin? Tar isteach: Who is there? Come in.'

Pearse stood up from the fire. In a moment the Hall was flooded with light. He stood there blushing a little and smiling. At the fire two small boys sat staring into the blaze.

Reference: Kenneth Reddin, 'A Man Called Pearse', in *Studies*, June 1943, p. 247

Sgoil Éanna, Ráť Feaṗnáin: An halla móṗ.
St. Enda's College. Rathfarnham : The Study Hall.

The house also contained a small oratory. Scoil Éanna was a Catholic school and Pearse was anxious to stress that it was run under the superintendence of a chaplain approved by the Archbishop of Dublin.

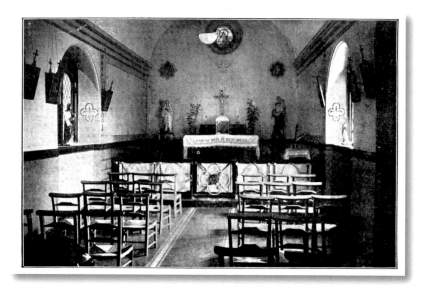

Pearse had ambitious ideas for the expansion of the school and had plans drawn up by the architect, and chronicler of Irish theatre, Joseph Holloway. However, he never had the funds to carry out much of the project, with the exception of this conservatory-style washroom.

The school contained its own museum, which housed a variety of exhibits, from industrial samples and botanical specimens to historical artefacts and letters. One of the boys was elected each year to act as the museum's curator. An article in *An Claidheamh Soluis* in August 1913 makes reference to a piece of Elizabethan armour and a cannon ball from the siege of Limerick presented to the school by Rev. T. Lee. When the folklorist and writer Ella Young visited the school to lecture the boys, she described being shown the museum:

> When the talk is over, Pearse shows me through the high-ceilinged rooms of the beautiful old house. In one room he has established a collection of weapons that have lived through hazardous times and high adventures: a cannon-ball from the siege of Limerick; pikes with hand-hammered iron heads that were carried in the '98 Rising; swords and pistols treasured once in mountain caves, or in camps of the Wild Geese in France. The boys are allowed to handle these things. And so was I.

References: *An Claidheamh Soluis*, 23 August 1913; Ella Young, *Flowering Dust*, p. 112

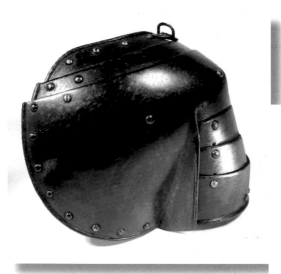

While Pearse frequently wrote of his educational adventure in Scoil Éanna in a high-flown and romantic way, the teaching was often very practical and the boys were encouraged to learn through experience.

The teaching aid shown here was part of a series called 'Object Lessons', which were produced by Cox and Co., London. In this example we see the method of growing and processing rubber. The rubber trade became notorious in the early twentieth century, as reports emerged of the brutal and inhumane treatment of the indigenous populations in Central Africa

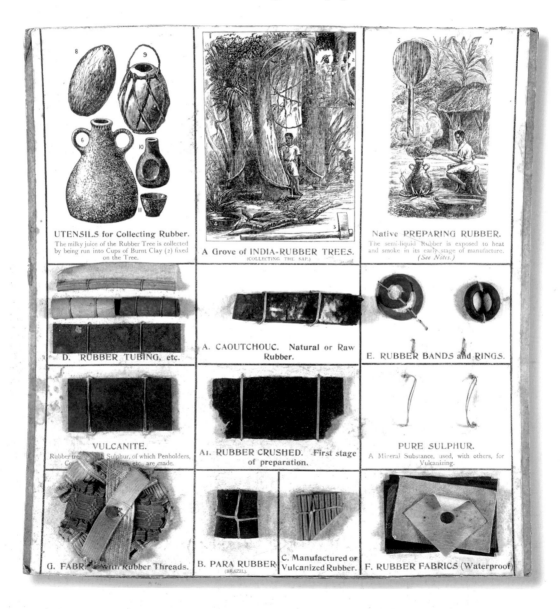

UTENSILS for Collecting Rubber.
The milky juice of the Rubber Tree is collected by being run into Cups of Burnt Clay (2) fixed on the Tree.

A Grove of INDIA-RUBBER TREES.
(COLLECTING THE SAP.)

Native PREPARING RUBBER.
The semi-liquid Rubber is exposed to heat and smoke in its early stage of manufacture.
(See Notes.)

D. RUBBER TUBING, etc.

A. CAOUTCHOUC. Natural or Raw Rubber.

E. RUBBER BANDS and RINGS.

VULCANITE.
Rubber treated with Sulphur, of which Penholders, Combs, Buttons, etc., are made.

A1. RUBBER CRUSHED. First stage of preparation.

PURE SULPHUR.
A Mineral Substance, used, with others, for Vulcanizing.

G. FABRIC with Rubber Threads.

B. PARA RUBBER (BRAZIL).

C. Manufactured or Vulcanized Rubber.

F. RUBBER FABRICS (Waterproof)

and the Amazon Basin, who were forced to harvest rubber by European companies under threat of mutilation and death. This teaching aid makes no reference to these issues and it is somewhat surprising to find it in Scoil Éanna, given the school's anti-imperial ethos.

Sir Roger Casement played a leading role in exposing the evils of the rubber trade in the Belgian Congo. He is pictured on the left of the photograph below, which was taken during his time in Central Africa. Casement was an important supporter of Scoil Éanna. He visited the school in 1910 to speak to the students about the Irish Revival and left a penknife as a prize for the best essay in Irish written about his lecture. At that time Casement was engaged in another investigation into human rights abuses in the Putamayo region in Peru. He brought back two boys from Putamayo to help raise awareness of the treatment of their people. Pearse agreed to enrol one of the boys, Omarino, in Scoil Éanna, but Casement changed his mind and returned with him to South America in 1911. Casement was later to be executed as a result of his involvement in the preparations for the 1916 Rising. (Image of Casement courtesy of Kilmainham Gaol/OPW)

This timetable for the school is written in Pearse's own handwriting. Classes were scheduled Monday to Saturday and covered subjects such as Christian Doctrine, Latin, French, Irish, English, Arithmetic, Drawing and Nature Study. Athletics and Carpentry were scheduled for an hour a week. Double periods for hurling or football were scheduled for Wednesday and Saturday.

Sgoil Éanna.

Réim Oibre na Seaċtṁaine, 1912 - 13.

In the Christmas edition of *An Macaomh* from 1910, Pearse published a poem about his belief in the almost sacred nature of the teacher's role. Initially written in Irish under the title '*Nior Cruinngheadh liomsa Ór*', he later translated it under the title '*I Have Not Garnered Gold*'.

I Have Not Garnered Gold

I have not garnered gold;
The fame I found hath perished;
In love I got but grief
That withered my life;

Of riches or of store
I shall not leave behind me
(Yet I deem it, O God, sufficient)
But my name in the heart of a child.

I Have not Garnered Gold.

I have not garnered gold;
The fame I found hath perished;
In love I got but grief
That withered my life;

Of riches or of store
I shall not leave behind me
(Yet I deem, O God, sufficient)
But my name in the heart of a child

The decision to move Scoil Éanna to Rathfarnham allowed Pearse the opportunity to set up a sister school for girls in the vacated Cullenswood House. The new school was called Scoil Íde (St Ita's College).

The page from *An Macaomh* from Christmas 1910 opposite features photographs of some of Scoil Íde's pupils. Among them were Mary Bulfin, the sister of Eamonn Bulfin, and Kitty Kiernan, who later became engaged to Michael Collins.

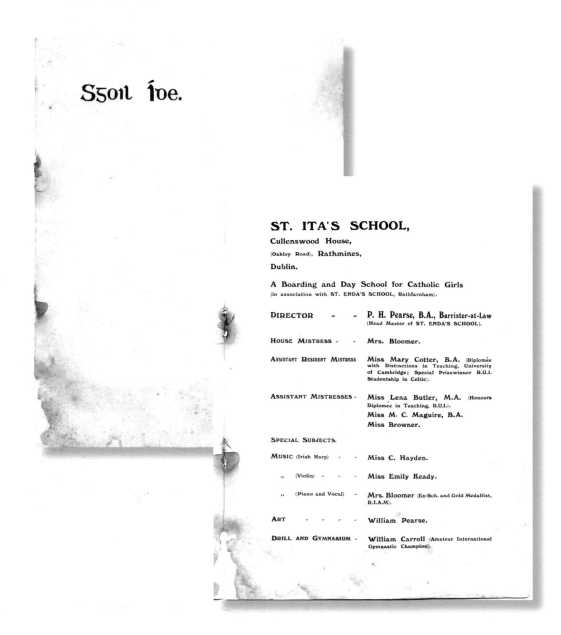

Sgoil Íde.

ST. ITA'S SCHOOL,

Cullenswood House,

(Oakley Road), Rathmines,

Dublin.

A Boarding and Day School for Catholic Girls
(in association with ST. ENDA'S SCHOOL, Rathfarnham).

DIRECTOR - -	**P. H. Pearse, B.A.,** Barrister-at-Law (Head Master of ST. ENDA'S SCHOOL).
HOUSE MISTRESS - -	Mrs. Bloomer.
ASSISTANT RESIDENT MISTRESS	Miss Mary Cotter, B.A. (Diplomée with Distinctions in Teaching, University of Cambridge; Special Prizewinner R.U.I. Studentship in Celtic).
ASSISTANT MISTRESSES -	Miss Lena Butler, M.A. (Honours Diplomée in Teaching, R.U.I.). Miss M. C. Maguire, B.A. Miss Browner.

SPECIAL SUBJECTS.

MUSIC (Irish Harp) - -	Miss C. Hayden.
„ (Violin) - - -	Miss Emily Keady.
„ (Piano and Vocal) -	Mrs. Bloomer (Ex-Sch. and Gold Medallist, R.I.A.M).
ART - - - -	William Pearse.
DRILL AND GYMNASIUM -	William Carroll (Amateur International Gymnastic Champion).

caitlín nic tiżeaRnáin.
KATHLEEN KIERNAN (School Captain).

máiRe builfin.
MARY BULFIN (CAPTAIN OF GAMES).

máiRe ciosóg.
MARY CUSACK (School Secretary).

eilis nic ainoiRiais.
ELSIE ANDREAE (School Librarian).

SGOIL IDE'S LEADERS.

87

Pearse's partner in the school was its headmistress, Mrs Gertrude Bloomer. Pearse would visit on a Wednesday afternoon to lecture the girls, and many of the Scoil Éanna teachers also taught there. The girls and boys of the two schools would often come together for ceilís and other cultural events.

Financially the school was not a success and it closed in 1912. Mrs Bloomer lost a considerable amount of money, which Pearse tried to pay back over the following years. One of the last letters he wrote the night before he left Rathfarnham to fight in the Rising was to Mrs Bloomer and included a cheque for five pounds. (Image courtesy of Kilmainham Gaol/OPW)

The poet Padraic Colum and his future wife, Mary Maguire, were both involved in Pearse's schools. Writing about her time teaching in Scoil Íde, Mary Colum commented on the interesting group of teachers and lecturers Pearse assembled to assist him in his schools:

Not all of us, I am very sure, were equal to what he wanted, but at least we responded to his ideas. He himself was the most high-minded person I have ever known; it was unthinkable that he should ever have a mean thought or done a mean action; it was even hard for him to imagine others doing them.

Reference: Mary Colum, *Life and the Dream*, p. 153

Although popular with the pupils and staff, Thomas MacDonagh did not want to be a school teacher and left the school in 1910 to spend time in Paris. He returned to Scoil Éanna in January 1911, but lived outside the grounds, in the gate lodge of Marley Grange House. He left Scoil Éanna permanently in 1912 when he took up a post in University College Dublin.

MacDonagh married Muriel Gifford, whom he first met when she and her sisters were brought to visit the school by the suffragette Mrs N. F. Dryhurst. Pearse was invited to their wedding and was asked to serve as a witness, but apparently he forgot to turn up. However, a year later, when he was cycling into the city from Rathfarnham, he stopped to say a prayer in the Church of the Three Patrons in Rathgar and came across the baptism of the MacDonaghs' oldest son, Donagh. Sydney Gifford, a sister of Muriel, later reported that MacDonagh said, 'Well you got here in time for the christening, anyway.' (Image courtesy of Kilmainham Gaol/OPW)

Reference: Sydney Gifford Czira [John Brennan], *The Years Flew By*, pp. 18–19

In March 1911 Professor David Houston, a neighbour of Pearse in Rathfarnham and an occasional guest lecturer at the school, set up a monthly magazine called *The Irish Review* with the help of the writer James Stephens and three Scoil Éanna/Scoil Íde staff members – Thomas MacDonagh, Padraic Colum and Mary Maguire (later Mary Colum). The editing duties were initially shared by all five founders, but in 1912 Padraic Colum became chief editor.

The magazine covered Irish literary, political, social, cultural and economic affairs. Much of Pearse's later literary and scholarly work was published in the magazine. Other contributors included Æ (George Russell), Edward Martyn, George Moore, Standish O'Grady, Arthur Griffith and Tom Kettle. Illustrations were provided by Jack Yeats, Nathaniel Hone, Casimir Markievicz and Augustus John.

Despite its impressive contributors, the magazine failed to break even. James Stephens moved to Paris in May 1912 and David Houston sold it to Joseph Plunkett in 1913. Plunkett took over the editorship from Padraic Colum. Under his leadership, aided by his friend Thomas MacDonagh, the magazine became increasingly concerned with political matters, particularly in relation to the Irish Volunteers. Its more partisan, radical point of view alienated many of its subscribers and it eventually ceased publication in 1914.

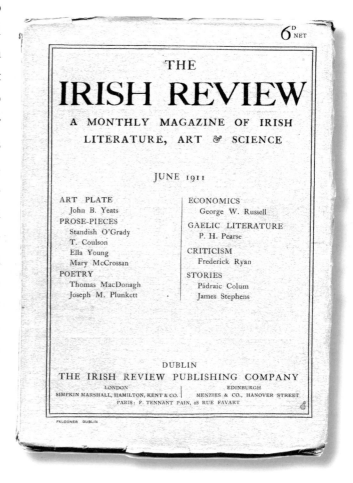

Pearse's Irish-language *Passion Play*, which told the story of the crucifixion of Christ, was performed on 7–8 April 1911 in the Abbey Theatre. The staging, design and acting of the piece was highly praised and it was one of the most successful of the school's theatrical productions.

The actors were mostly teachers and pupils from Pearse's two schools, Scoil Éanna and Scoil Íde. Thomas MacDonnell played Christ and also composed some of the incidental music. Mary Bulfin was the Virgin Mary and Mary Colum played Mary Magdalen. Pearse himself played the impenitent thief, while Thomas MacDonagh was the good thief. The school gardener and horticultural instructor, Mícheál Mac Ruaidhrí, donned a leopard-skin pelt and played Barabbas, while Willie Pearse, pictured here in this souvenir postcard from the play, was Pontius Pilate.

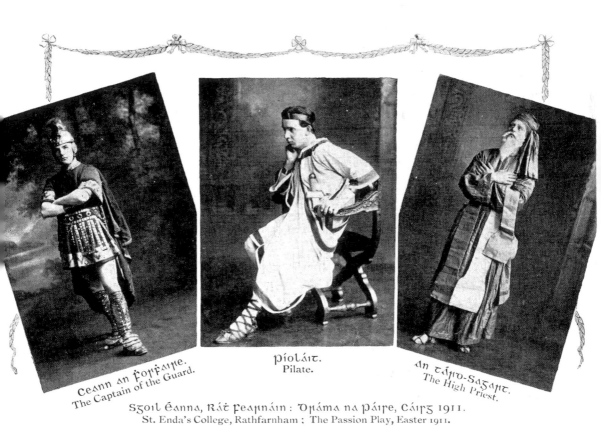

Ceann an ḟoṁaire.
The Captain of the Guard.

píoláit.
Pilate.

an táro-Saṡant.
The High Priest.

S�5oil Éanna, Ráṫ ḟeaṁnáin : Oṁáma na páiṁe, Cáiᴦ5 1911.
St. Enda's College, Rathfarnham ; The Passion Play, Easter 1911.

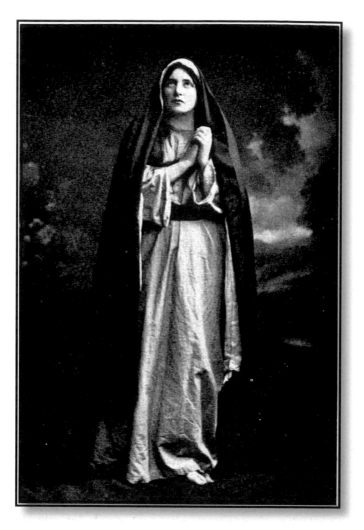

Mary Bulfin was striking in her depiction of the Virgin Mary. Mary Colum said she looked like a painting by Murillo. When Mary Bulfin recalled the production over twenty years later she remembered how Pearse had directed the piece:

> Mr. Pearse didn't seem to worry much about rehearsals. He told us simply and clearly what he wanted done; and once he was sure that each one really knew what he or she had to do, he was satisfied. He seemed to have a divine belief that everyone would rise to the occasion and perform their individual parts adequately at the actual performance, no matter how woodenly they behaved at the rehearsals. It was part of his general belief in human nature, I think.

Reference: Mary Brigid Pearse (ed.), *The Home-Life of Pádraig Pearse*, pp. 155–6

Impromptu snapshots of Pearse are rare. In this image he is shown holding his bicycle pump. Pearse would regularly cycle into the city. While he loved living with the wild countryside of the Dublin Mountains on his doorstep, he was also anxious to remain involved in the cultural and political events which took place in the city. (Image courtesy of Kilmainham Gaol/OPW)

The Scoil Éanna enterprise was always plagued by funding problems and the decision to move to Rathfarnham and expand his operation by opening a girls school in Cullenswood at the same time proved disastrous. Pearse could not afford the lease on The Hermitage, nor the building alterations it required. Rathfarnham also proved too far away for many day pupils, resulting in a decline in both numbers and revenue. This page comes from his account book from around 1912. Pearse remained under huge financial pressure for the rest of his life.

One scheme to stave off financial ruin was the establishment of Scoil Éanna Ltd in January 1912. Shares in the company were sold to well-wishers who wanted to support Pearse in his enterprise. This share receipt was issued to Sir Bertram Windle, who served as President of Queen's College Cork (now University College Cork) between 1904 and 1919.

However, by the middle of 1912 it was clear that the setting up of Scoil Éanna Ltd had not solved the school's problems. The company went into liquidation, resulting in losses for all the investors and the many creditors. Pearse managed to secure sufficient funds to buy the company from the liquidator, but in the years that followed the school lurched from crisis to crisis and never managed to be a going concern. This letter from Eastmans Ltd is typical of hundreds Pearse received from angry and despairing businesses looking for payment.

Pearse spent little on himself during these years. His one weakness was his books.

> He loved his books: that much-read edition of the *Cattle Spoil of Cuailgne* and his many editions of Shakespeare, all of which he had watched in the book-sellers' windows, nobly renounced, entered, fingered, steeled himself, fled whole streets away, lingered, wavered, turned back and purchased, radiant and ashamed until he saw the next.

Reference: Desmond Ryan, *Remembering Sion: A Chronicle of Storm and Quiet*, pp. 159–60

Both images on this page show Scoil Éanna pupils.

Back row (left to right): Joseph Sweeney, Peter Butler, Augustine Geary. *Front row:* Eunan McGinley, — Callaghan. Both Joseph Sweeney and Eunan McGinley went on to fight in the 1916 Rising.

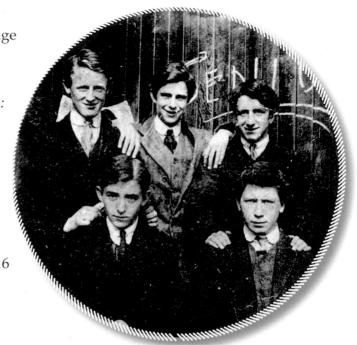

Left to right: Eddy Boyle, — O'Neill, Eunan McGinley, Joseph Sweeney, A. Gaynor, — Murphy and Eoin MacGavock. MacGavock was the son of Eoin MacNeill's sister, Annie. He later went to sea and was killed in the horrific Halifax Explosion on 6 December 1917, when a French cargo ship loaded with explosives collided with another vessel in Halifax Harbour in Canada. Nearly 2,000 people were killed in the resulting explosion.

Pearse set his morality play *An Rí* (The King) among a group of boys studying in a monastery in medieval Ireland. The local king is marching to war but the abbot prophesies that he will be defeated as he has 'forsaken the friendship of God and made friends with evil-doers'. Victory will only be possible if he abdicates in favour of one who is pure of heart. The only one found worthy of the task is a young boy named Giolla na Naomh, who leads the kingdom into battle and dies on the field.

The play was performed in the grounds of St Enda's in 1912. The garden buildings and follies, like Emmet's Fort and the castellated bridge, provided a backdrop for the production and it was widely praised. The roll of Giolla na Naomh was taken by Desmond Carney (*pictured*), who was later Professor of Mathematics in Marquette University in Wisconsin.

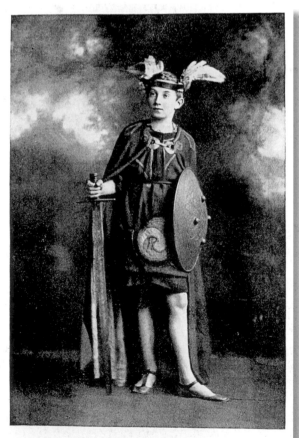

DESMOND CARNEY AS " GIOLLA NA NAOMH " IN AN RI, ST. ENDA'S COLLEGE, JUNE, 1912.

Desmond Carney also played the lead in another short play by Pearse called *Eoin*, which was performed in the Mansion House in Dublin and at a Gaelic League winter ceilí in 1913. Pearse published an English translation of it in December 1915 under the title *Owen*. It appeared in *Fianna*, the newspaper of the nationalist youth movement Fianna Éireann, and was illustrated with an image of Desmond Carney in costume and posing with a rifle.

The play was set on the eve of the 1867 Fenian rebellion and told the story of Owen, a young boy who discovers his village schoolmaster is secretly a rebel and hiding a cache of arms under the floorboards of the schoolhouse. His teacher shows him how to operate a rifle, but, despite Owen's pleadings, he refuses to allow him to join in the uprising. Owen spots the arrival of some policemen and the teacher makes his escape. As they bang on the door, Owen takes up a rifle and fires at the door, hoping to hold off the police. They respond with a volley of shots, killing the boy. (Image courtesy of the National Library of Ireland)

16 FIANNA. DECEMBER, 1915,

OWEN.

Translated from the Irish of P. H. PEARSE.

[NOTE.—I have translated into English for "Nodlaig na bhFiann" a little dramatic episode which I wrote in Irish for my pupils of St. Enda's College and which they performed at Ceilidhe in the Dublin Mansion House in the winter of 1913, and at a Ceilidhe in the Hall of the Colmcille Branch of the Gaelic League. Companies of the Fianna may find the English version suitable for performance at some of their Ceilidhthe. At the St. Enda's performance we gave the play a western setting, the bigger boys wearing bawneens and the smaller boys the long frocks worn by children in the Connacht Gaedhealtacht. "The Hawk o' the Hill" was the name given to James Stephens, the Chief Organiser of the Irish Republican Brotherhood. Stephens had left Ireland in 1866, but his name would still be used as a watchword by his followers.]

PERSONS.

A SCHOOLMASTER.
SHAWN.
DARACH.
PATRICK.
OWEN.
OTHER BOYS.
A BALLADSINGER.
POLICEMEN.
TIME—MARCH 4th, 1867.

A country schoolhouse. There is a door at the back, with a window beside it; another window to the right. The boys' caps and satchels hang on pegs on the wall. The MASTER is seated at his desk, reading. A class of older boys is working on slates in the benches; some smaller boys are writing on copybooks.

THE MASTER (raising his eyes from his book)—Has anyone finished yet? Well, Shawn?

SHAWN—No, sir; not yet.

THE MASTER—Hurry up now like good lads. When you've that one done I'll let you home; it is on the stroke of three. (Reads to himself.) "Whether in the attack or in the defence cover is all-important. Cover is of two kinds: cover from fire and cover from view. An ordinary hedge, a comparatively small embankment, a loose stone wall, a mere depression in the ground, will afford cover from view. For effective fire cover ———."

The voice of a BALLADSINGER singing "The Wearin' o' the Green" is heard. The MASTER and the boys listen. The singer seems to be at a little distance at first. When he starts the second stanza, "I met with Napper Tandy," he has apparently come up to the school door, and he sings clearly and loudly. As soon as the second stanza is finished a knock is heard at the door.

THE MASTER—Open the door, Shawn.

SHAWN rises and opens the door. A BALLADSINGER with ballads in his hand comes into the schoolroom. SHAWN returns to his bench.

THE BALLADSINGER—God save all here.

THE MASTER—God any Mary save you.

THE BALLADSINGER—Would you buy a ballad from me, Master?

THE MASTER—What ballads have you got?

THE BALLADSINGER — I've got "The Wearin' o' the Green," and "The Lambs on the Green Hills," and "Bold Robert Emmet."

THE MASTER—Give me "Bold Robert Emmet."

THE BALLADSINGER—Here you are, my jewel. A grand song (he hands a ballad to the MASTER, who gives him a penny). God spare you your health. (Coming closer to the MASTER, and speaking in a low voice). Are you Malachy Hession, schoolmaster of this place?

THE MASTER—I am.

THE BALLADSINGER—I've got a message for you.

THE MASTER—Who is the message from?

THE BALLADSINGER—From them that, you know.

THE MASTER—Give me a sign.

THE BALLADSINGER—Did you ever hear tell of the Hawk o' the Hill?

THE MASTER—I did.

THE BALLADSINGER—I am one of his friends.

THE MASTER—Who do you come from?

THE BALLADSINGER—I was in a house in Dublin. There came into it a short dark man by the name of Devoy. He was from Kill, in the County Kildare. He met you once at the fair of Oughterard.

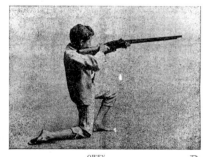

OWEN.
Desmond Carney as "Owen," St. Enda's College, Christmas, 1913.

THE MASTER—You may give me your message.

THE BALLADSINGER (slowly and emphatically)—This is the night.

THE MASTER—To-night?

THE BALLADSINGER—To-night.

THE MASTER—This is great news, man.

THE BALLADSINGER—Aye is it. There'll be balladsingers crying ballads of to-night's story when you and I are dead.

THE MASTER—I'll go down the boreen with you, and we can talk going down. The lads maybe would hear us if we talked here. (To the boys)—Work on, boys, till I come back.

THE MASTER and the BALLADSINGER go out. As soon as the door is closed SHAWN springs to his feet and runs to the window.

SHAWN—They're going down the boreen!

DARACH—Are they?

SHAWN—They're at the gate!

PATRICK—Dads!

SHAWN—They're going out on the road!

OWEN—Arrah, ye divils, let's have some fun!

DARACH—All right. Leap-frog!

They spring to their feet and play leap-frog round the room. At the height of the uproar OWEN seizes the MASTER's cane and mounts the rostrum.

OWEN—I'm to be the Master, lads! (striking the desk with the cane and mimicking the MASTER's voice). Silence, silence! (The boys sit down and pretend to work at the sum). Has anyone finished yet?

THE BOYS (shouting descordantly)—No, sir! Yes, sir! I, sir! You, sir!

OWEN (striking the desk)—Hold your tongues!

SHAWN—Hold your tongue yourself.

OWEN — Stand up, Shawn Johnny! (SHAWN stands up). Hold out your hand!

OWEN attempts to cane him but SHAWN withdraws his hand at each stroke. OWEN turns tail. OWEN is chasing SHAWN when the door opens and the MASTER enters. THE BOYS bolt back to their places, but OWEN is caught in the middle of the floor.

THE MASTER—What is all this about? What are you doing there?

OWEN—Nothing, sir.

THE MASTER—Give me that cane (OWEN gives it to him and the MASTER looks at him threateningly). You will go over there to the corner, and you will stay in after the other boys. (OWEN goes over to the corner and sits down on a bench, where he amuses himself by drawing caricatures of the MASTER on a slate). Well, boys, have you finished that sum?

SEVERAL OF THE BOYS—Yes, sir!

THE MASTER—What answer did you get, Patrick?

PATRICK—Six pounds seventeen shillings and threepence.

SHAWN—No, there's a halfpenny in it.

PATRICK—Oh, aye! Six pounds seventeen shillings and threepence halfpenny.

THE MASTER—The boys that got that answer will hold up their hands (several held up their hands). Good! I'll let you off now.

THE BOYS, with the exception of OWEN, take their books and caps, and go out, each saying "Good evening, sir," as he leaves.

THE MASTER — Good evening, boys. (When the last has gone out the MASTER stands in the doorway looking after them).

The child who is pure of heart and sacrifices himself for the good of his community is a recurrent theme in many of Pearse's plays. The boy-hero of *Owen* and Giolla na Naomh in *An Rí* can both be seen as martyrs; the idea is also evident in Pearse's later play, *The Master.* In his foreword to the May 1913 edition of *An Macaomh*, he wrote about a dream he had had four years previously: 'I dreamt that I saw a pupil of mine, one of our boys at St. Enda's, standing alone upon a platform above a mighty sea of people; and I understood that he was about to die there for some august cause, Ireland's or another.' He goes on to say that he could not wish for any of his pupils 'a happier destiny than to die thus in defence of some true thing'. He concludes by saying, 'Mr J. M. Barrie makes his Peter Pan say (and it is finely said) "To die will be a very big adventure" but I think in making my little boy in *An Rí* offer himself with the words, "Let me do this little thing", I am nearer to the spirit of the heroes.'

This image of Peter Pan comes from *Peter Pan in Kensington Gardens*, written by J. M. Barrie and illustrated by Arthur Rackham, which was first published in 1902. (Private Collection)

Reference: Patrick Pearse, *An Macaomh*, May 1913, pp. 6–7

Peter Pan is the fairies' orchestra.

In 1913 Pearse approached W. B. Yeats, seeking support for the school. Yeats agreed to put on a joint production in the Abbey Theatre of his translation of the Indian poet Rabindranath Tagore's play *The Post Office* and Pearse's morality play *An Rí*.

Tagore, shown here in a photograph from 1914, remains one of India's most popular poets and Yeats was a great admirer of his work. Tagore was also interested in education and set up a school in Bengal, which Yeats described as 'the Indian St. Enda's'. In 1915 Tagore wrote about a production of *An Rí* which formed part of his school's dramatic festival. The open-air production took place by moonlight, with the players wearing traditional Bengali costume. (Image of Tagore from a private collection)

Reference: Elaine Sisson, *Pearse's Patriots: St Enda's and the Cult of Boyhood*, p. 74

ABBEY THEATRE,
Special Performance in aid of the Building Fund of St. Enda's College.
Saturday, 17th May, 1913, at 8.15.
The Abbey Co. (2nd Co.) will produce "THE POST OFFICE," a play in two acts by RABINDRANATH TAGORE. The Students of St. Enda's College will produce "AN RI," a morality in one act by P. H. Pearse.
Stalls - - - - - 3s.
Seat may be reserved at Cramer's.

THE WEEK'S PROGRAMME.

MONDAY, June 9th.

7.30 p.m.	Gates Open. St. James's Brass and Reed Band plays.
8 p.m.	Dr. Douglas Hyde, escorted by O'Toole Pipers, declares Fête open.
8.15 p.m.	Al-fresco Concert.
9 p.m.	Dancing.
9.30 p.m.	Pageant of "The Defence of the Ford" by the Students of St. Enda's College assisted by 100 other performers.

TUESDAY, June 10th.

7.30 p.m.	Gates Open.
8 p.m.	Al-fresco Concert. Cumann na bPíobairi Pipers play.
8.45 p.m.	Dancing.
9.15 p.m.	Display by the Fianna Eireann.
10 p.m.	Pageant of "The Fianna of Fionn" by the Students of St. Enda's College.

WEDNESDAY, June 11th (Children's Evening).

7 p.m.	Gates Open. "Ireland's Own" Band plays. Children's Dancing.
7.30 p.m.	Al-fresco Concert and Display by the MacHale Children. O'Toole Pipers play.
8.45 p.m.	Dancing.
9.30 p.m.	Pageant of "The Defence of the Ford."

THURSDAY, June 12th.

7.30 p.m.	Gates Open. Irish National Foresters' Band plays.
8 p.m.	Al-fresco Concert. Lusk Pipers play.
8.45 p.m.	Dancing.
9.15 p.m.	Display by the Fianna Eireann.
10 p.m.	Pageant of "The Fianna of Fionn."

FRIDAY, June 13th.

7.30 p.m.	Gates Open.
8 p.m.	Al-fresco Concert. Cumann na bPíobairi Pipers play.
8.45 p.m.	Dancing.
9 p.m.	Display by the Fianna Eireann.
9.45 p.m.	Pageant of "An Rí" by the Students of St. Enda's College.

SATURDAY, June 14th.

2.30 p.m.	Gates Open.
3 p.m.	Annual Athletic Sports of St. Enda's College.
4 p.m.	St. James's Brass and Reed Band plays.
7.30 p.m.	Al-fresco Concert. St. James's Band and O'Toole Pipers play.
8.15 p.m.	Dancing.
8.45 p.m.	Pageant of "The Defence of the Ford."
9.45 p.m.	Parade of Bands and Torchlight Band Tattoo.

The Pageants are arranged by Mr. P. H. Pearse and produced by Mr. William Pearse.

The Music in the Pageants is composed and arranged by Mr. Thomas MacDonnell and sung under the direction of Mr. Eoghan O Briain.

The military movements in "The Defence of the Ford" are under the direction of Captain Colbert, of the Fianna Eireann.

The Fianna Eireann Displays are under the direction of Major Lonergan, Commanding the Dublin Fianna.

The Concerts are under the direction of Mr. Seán Cloinnsigh and Mr. Peadar Breathnach.

Pearse attempted to raise further funds in 1913 by running a week-long fête in the GAA grounds on Jones's Road. The event was not a success. It took place in June, but there was ceaseless rain every evening. Despite these downpours, a fire broke out on the final night. Joseph Holloway recounted a conversation he had with Pearse in which he described the adaptations they had to make as a result of the heavy rain: 'On Monday in *The Defence of the Ford* Cuchulainn's assailant was chased off the field and not slain as it was too wet to go through the death scene on the grass, the boys might catch cold.' Although he was usually supportive of the school, on this occasion Holloway was not impressed: 'There was a want of organisation about this Fête that depressed me – it lacked the dignity that should halo such an occasion – an Irish fête set up for the maintenance of an Irish College!' (Images courtesy of the National Library of Ireland)

Reference: Holloway papers, National Library of Ireland

Pearse regularly held an Aeridheacht or 'Open Day' at the school to promote Scoil Éanna. These events attracted many leading cultural figures to the school. This photograph was taken of those who attended an Aeridheacht *c.* 1914. Among the group were Douglas Hyde, Eoin MacNeill, Agnes O'Farrelly and Éamonn Ceannt. The second photograph shows an open-air pageant performed on that occasion, *Fionn: A Dramatic Spectacle*, which featured Willie Pearse (eighth from left).

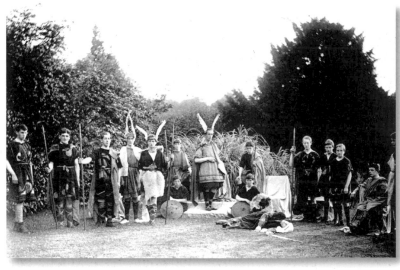

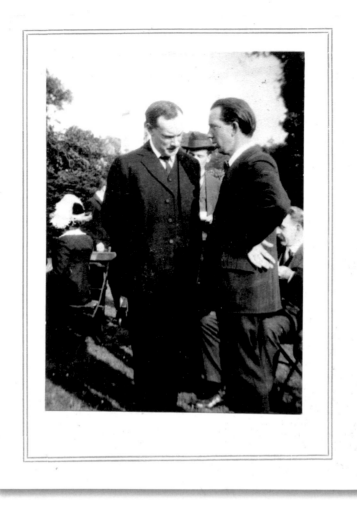

The Pearse brothers are pictured here, deep in conversation, at the school open day. Pearse's demeanour suggests the great financial worries that dogged him at this time. With less and less staff, Pearse increasingly depended on Willie when it came to the running of the school.

Despite its achievements, Pearse was disappointed with his great educational adventure. His initial high hopes that the school would change the face of Irish education had not been realised. Numbers were falling and it was no longer able to carry out the kind of innovative and exciting programme of activities which had characterised its early years. For Pearse it was increasingly clear that if he was to fulfil the kind of heroic destiny he had always imagined for himself, he would have to look beyond the boundaries of his beloved Scoil Éanna.

'THIS ROAD BEFORE ME':
THE PATH TO REBELLION

In December 1912 Pearse published his poem 'Fornocht do Chonac Thú' (Naked I Saw Thee) in *The Irish Review.* He later translated it under the title 'Renunciation'.

Naked I saw thee,
O beauty of beauty,
And I blinded my eyes
For fear I should fail.

I heard thy music,
O melody of melody,
And I closed my ears
For fear I should falter.

I tasted thy mouth,
O sweetness of sweetness,
And I hardened my heart
For fear of my slaying.

I blinded my eyes,
And I closed my ears,
I hardened my heart
And I smothered my desire.

I turned my back
On the vision I had shaped,
And to this road before me
I turned my face.

I have turned my face
To this road before me,
To the deed that I see
And the death I shall die.

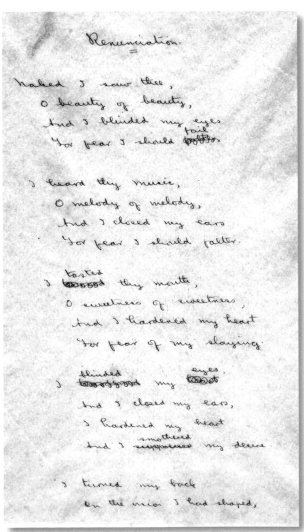

The prophetic quality of this poem was often commented on after Pearse's death. It also reflects his desire to completely and unreservedly commit himself to a worthy cause.

Despite the considerable financial difficulties his schools were experiencing at the time, Pearse launched a new Irish-language newspaper, *An Barr Buadh* (The Trumpet of Victory) in 1912. The title came from the legendary horn which Fionn would blow to rally his followers in the Fianna. Pearse's decision to start a newspaper reflected his increasing engagement with contemporary issues and his desire to play a role in the political life of Irish society. Pearse saw the passing of the third Home Rule Bill in 1912 as an opportunity for real change in Irish society.

The paper lasted for eleven issues, each consisting of four pages only. Although Pearse wrote the majority of the paper's content, there were also contributions from Con Colbert, Physical Education teacher in Scoil Éanna; the composer and former Scoil Éanna staff member, Thomas McDonnell; and Éamonn Ceannt, a Gaelic Leaguer who worked as a clerk in Dublin Corporation. Ceannt's son Ronán attended Scoil Éanna. Ceannt would later be one of Pearse's fellow signatories of the 1916 Proclamation.

Pearse wrote a series of 'open letters' to well-known Irish figures in the columns of *An Barr Buadh* under the pseudonym 'Leagh Mac Riangabhra'. The first letter was addressed to John Redmond, the leader of the Irish Parliamentary Party, pictured (*right*). Pearse and his father both supported Charles Stewart Parnell when the party split in 1895, and in his letter it was clear that Pearse's sympathies lay with the Parnellite faction.

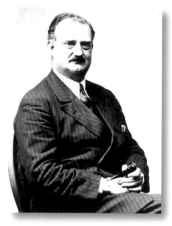

Pearse spoke in favour of the Home Rule Bill at an Irish Parliamentary Party rally on 31 March 1912. The other speakers were Eoin MacNeill, John Redmond MP and Joseph Devlin MP, pictured below (*left*) in the company of John Dillon MP. Although Home Rule fell far short of Pearse's vision of Irish freedom, he saw it as a positive step and he was particularly enthusiastic about the control of Irish education being devolved to a Home Rule parliament. In contrast to this support for moderate politics, Pearse concluded his speech with a violent warning: 'Let the English understand that if we are again betrayed there shall be red war throughout Ireland.' (Image of Redmond courtesy of Mercier Archive; image of Dillon and Devlin courtesy of Cashman Collection/RTÉ Stills Library)

Reference: *An Barr Buadh*, 5 April 1912

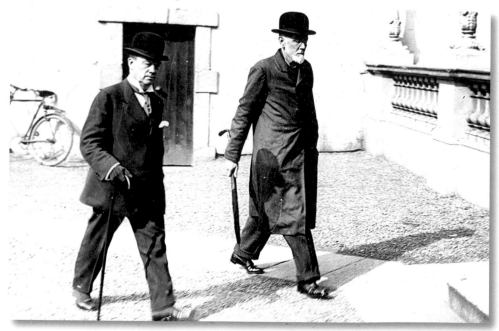

Pearse also addressed open letters to John Dillon and William O'Brien MP. He called on O'Brien and Dillon to put aside their rivalries and unite the Irish Parliamentary Party. O'Brien is pictured here (*right*) walking with Tim Healy MP, whom Pearse accused in an open letter of 27 April 1912 of being a source of vexation and anguish to his countrymen. Although Pearse does not substantiate his criticisms of Healy, they probably refer to Healy's role as the most vocal and invective critic of Parnell, and his tendency to ferment rifts within the Home Rule movement. (Image courtesy of Cashman Collection/ RTÉ Stills Library)

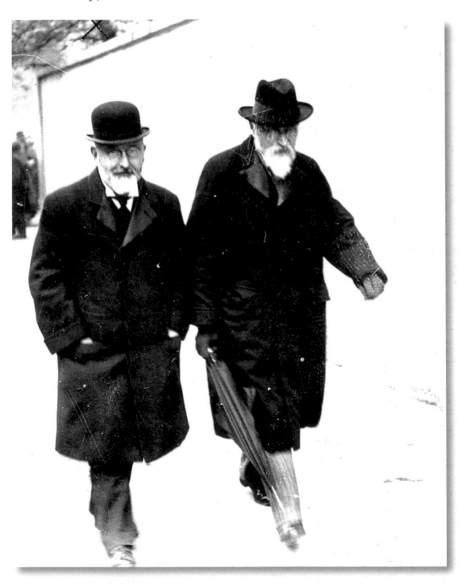

Other addressees of Pearse's open letters in *An Barr Buadh* included Douglas Hyde, Arthur Griffith and Tom Kettle, the academic and Home Rule MP. Perhaps the most remarkable letter is one he addressed to himself on 11 May. It is almost brutal in its honesty and reveals Pearse's deep-seated unease with himself:

I don't know if I like you or not, Pearse. I don't know if anyone does like you. I know full well many who hate you … Pearse, you are too dark in yourself. You don't make friends with the Gaels. You avoid their company. When you come among them you bring a dark cloud with you that lies heavily on them … Is it your English blood that is the cause of this I wonder? However you have the gift of speech. You can make your audience laugh or cry as you please. I suppose there are two Pearses, the sombre and taciturn Pearse and the gay and sunny Pearse. The gay and sunny Pearse is seen too seldom, and generally at public meetings and in Scoil Éanna … I don't like that gloomy Pearse. He gives me the shivers. And the most curious part of the story is that no one knows which is the true Pearse … You did a good deed when you founded St. Enda's and St. Ita's. Take my advice, attend to those, leave politics alone, and throw away your *Trumpet of Victory* (Barr Buadh).

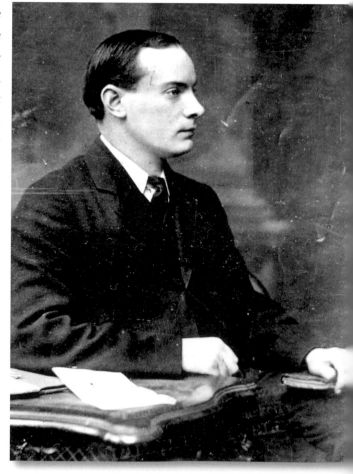

Reference: Louis N. Le Roux, *Patrick H. Pearse*, pp. 40–1

On 22 June 1913 Pearse gave the annual oration at the grave of Wolfe Tone in Bodenstown, County Kildare. In his speech he called on his audience to pledge themselves to 'follow in the steps of Tone, never to rest, either by day or by night, until his work be accomplished, deeming it the proudest of all privileges to fight for freedom'. His oratorical skills and his devotion to the ideals of Tone, Emmet and the Irish republican tradition brought him to the attention of the leadership of the Irish Republican Brotherhood (IRB), a secret organisation devoted to achieving Irish independence through force of arms.

Reference: Patrick Pearse, *The Complete Works of P.H. Pearse: Political Writings and Speeches*, p. 63

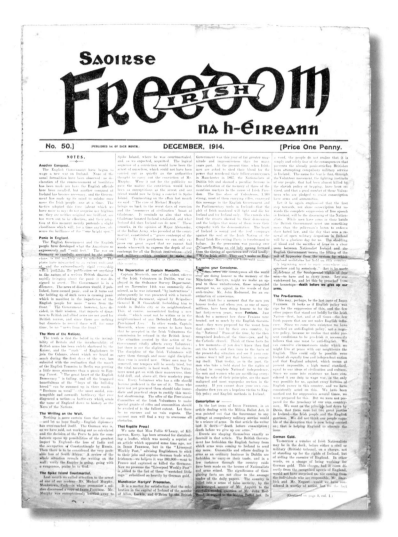

Between June 1913 and January 1914 Pearse published a series of articles in the IRB-controlled *Irish Freedom* newspaper, under the title 'From a Hermitage'. He republished them as a pamphlet in June 1915 and said in his preface that this had been 'a period which, when things assume their proper perspective, will probably be regarded as one of the most important in recent Irish history'. The 1913 Lockout and the foundation of the Irish Volunteers saw an increasing militarisation and radicalisation of Irish society. Pearse was not immune to these changes and this period was crucial to his move from being a political moderate and supporter of Home Rule to becoming a militant separatist.

Reference: Patrick Pearse, *The Complete Works of P.H. Pearse: Political Writings and Speeches*, p. 141

The title 'From a Hermitage' came from the name of Pearse's home in Rathfarnham. The original owners erected a hermit's cave in the grounds, which is pictured here. However, there was no historical basis for the name or the idea that a hermit lived there. It was meant to suggest the idea of a retreat from the hustle and bustle of the world. The persona Pearse adopted was that of a detached observer, commenting on the events of the day from the serenity of his hermitage. The tone of these articles is often playful and humorous. For example, in the opening paragraph of his first article in June 1913 he says, 'I have only two qualities in common with the real (or imaginary) hermit who once lived (or did not live) in this place: I am poor and I am merry.' This lightness of tone is in contrast with the solemnity and seriousness which characterised his later political writings. (Image courtesy of Jonathan Callan)

Reference: Patrick Pearse, *The Complete Works of P.H. Pearse: Political Writings and Speeches*, p. 143

Many of the earlier articles addressed cultural issues such as Arthur Griffith (*pictured, left*) and Sinn Féin's campaign against Douglas Hyde's leadership of the Gaelic League. In September's article he considered the Irish cultural scene and compared some of its leading figures to different types of beetle. W. B. Yeats (*pictured, right*) is like the *Necydalis Major*, long and graceful, while Lady Gregory is the *Coccinella*, pleasant and comfortable-looking. However, he identified the novelist and diarist George Moore as the *Creophilus Maxillosus*, a creature which haunts, drains and feeds on garbage. Pearse's attack on Moore was in reaction to the preface Moore wrote for his brother Maurice's biography of their father, George Henry Moore. George Henry Moore was a landlord based in County Mayo who had worked tirelessly to organise relief for his tenants during the Famine. He was also a Catholic convert and a member of the Fenian Brotherhood. Pearse admired him and said he had worked manfully for Ireland. He accused George Moore of portraying his father as a 'blackguard'. This preface also led to a rift between the Moore brothers which was never healed. (Image of Griffith courtesy of Kilmainham Gaol/OPW)

Reference: Patrick Pearse, *The Complete Works of P.H. Pearse: Political Writings and Speeches*, pp. 156–64

 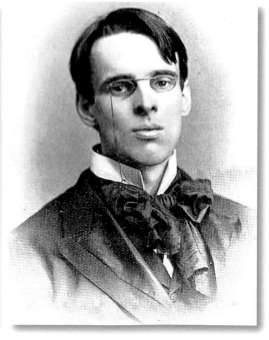

In July 1913 Pearse addressed the issue of symbols: 'No one in Ireland either likes or dislikes George Wettin [George V]; yet every true man of Ireland hates, or should hate, to see his not very intellectual features on a coin or on a stamp, for they symbolise there the foreign tyranny that holds us.' (Image of pennies from a private collection; image of envelope courtesy of Kilmainham Gaol/OPW)

Reference: Patrick Pearse, *The Complete Works of P.H. Pearse: Political Writings and Speeches*, pp. 151–2

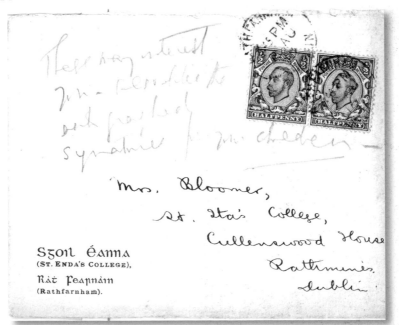

Pearse supported workers and their unions against their employers during the strike, or Lockout, which broke out in August 1913. He stated in his October column that 'I am nothing so new-fangled as a socialist or a syndicalist', but that his instinct was with 'the breadless man against the master of millions'. The strike was led by James Larkin, whose sons were later pupils in Scoil Éanna.

The Dublin Metropolitan Police began to attack and break up union rallies and pickets. This photo shows the notorious Bloody Sunday in August 1913, when the police charged a crowd of workers and their supporters on Sackville (now O'Connell) Street as Larkin was illegally addressing them from the balcony of the Imperial Hotel. (Image courtesy of Mercier Archive)

Reference: Patrick Pearse, *The Complete Works of P.H. Pearse: Political Writings and Speeches*, pp. 176–7

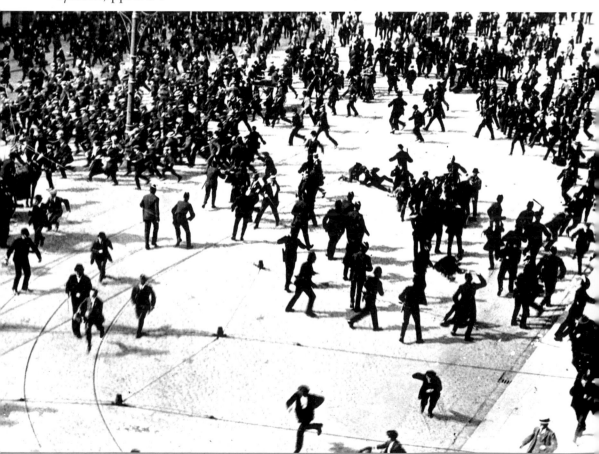

On 2 September 1913 two tenement houses on Church Street in Dublin city centre collapsed, killing seven people. Pearse used this event to highlight the appalling living conditions of Dublin's poor:

> There are tenement rooms in Dublin in which over a dozen persons live, eat and sleep. High rents are paid for these rooms, rents which in cities like Birmingham would command neat four roomed cottages with gardens. The tenement houses of Dublin are so rotten that they periodically collapse upon their inhabitants, and if the inhabitants collect in the streets to discuss matters the police baton them to death.

(Image courtesy of the Royal Society of Antiquaries of Ireland)

Reference: Patrick Pearse, *The Complete Works of P.H. Pearse: Political Writings and Speeches*, p. 178

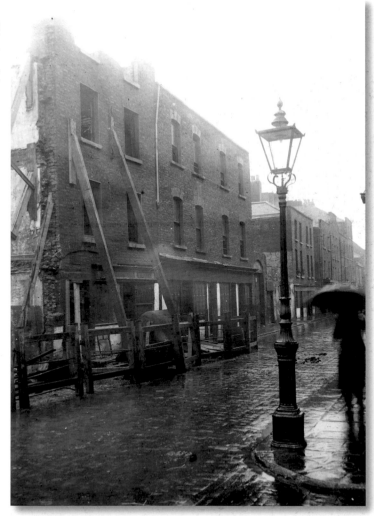

In 1913 the Ulster Volunteer Force (UVF) was established as a voluntary armed militia to resist the imposition of Home Rule in Ireland. Pearse said that 'it is foolish of an Orangeman to believe that his personal liberty is threatened by Home Rule; but, granting that he believes that, it is not only in the highest degree common sense but it is his clear duty to arm in defence of his threatened liberty'. Pearse thought an 'Orangeman with a rifle a much less ridiculous figure than the Nationalist without a rifle'.

This image shows unionist leader Edward Carson speaking at an anti-Home Rule rally. (Image courtesy of Kilmainham Gaol/OPW)

Reference: Patrick Pearse, *The Complete Works of P.H. Pearse: Political Writings and Speeches*, p. 185

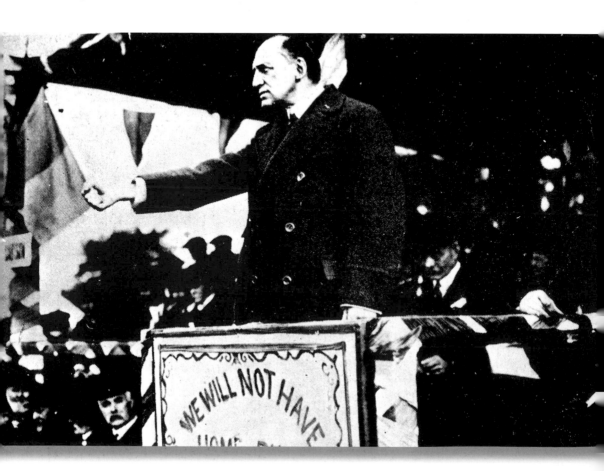

In October 1913 Eoin MacNeill published an article called 'The North Began' in *An Claidheamh Soluis*. It called on Nationalist Ireland to take its lead from the unionists of Ulster and set up an Irish Volunteer Force (IVF) to defend Home Rule. Pearse was one of the founder members of this new force, which was inaugurated at a meeting on 25 November in the Rotunda Rink, Dublin. Three thousand men signed up to join at that first meeting. Pearse saw the setting up of the Volunteers as a transformative moment for Ireland and an opportunity for the renewal of the soul of the nation. In his last 'From a Hermitage' article he wrote that as a result of the formation of the Volunteers: 'we are as men who, having wandered long through the devious ways of a forest, see again the familiar hills and fields bathed in the light of heaven, ancient yet ever-new'. The image below shows a large group of Irish Volunteers on parade. (Image courtesy of Kilmainham Gaol/OPW)

Reference: Patrick Pearse, *The Complete Works of P.H. Pearse: Political Writings and Speeches*, p. 211

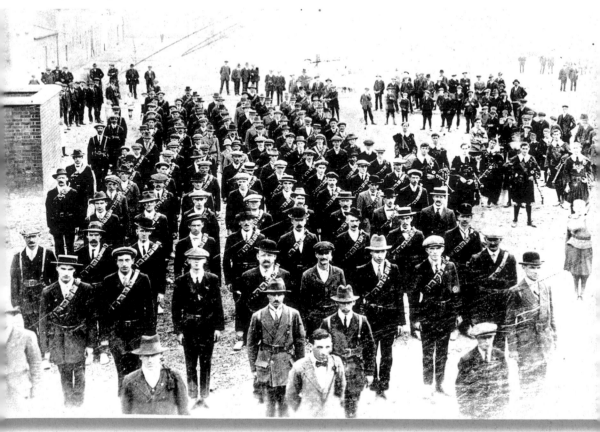

Pearse quickly assumed a leading role in the new Volunteer movement and travelled the country encouraging new members and the creation of new branches. He also led his local branch of the Volunteers in Rathfarnham. This photograph shows them lined up at their mustering point at the Roman Catholic parish church in Rathfarnham.

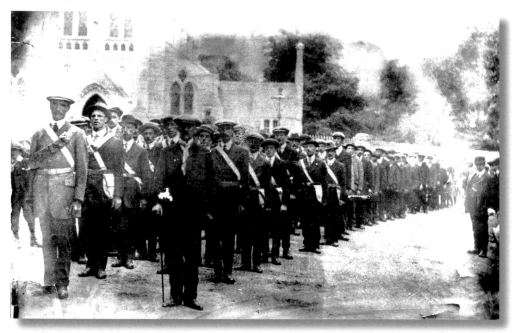

Pearse threw himself into his work with the Irish Volunteers. His main contribution was as a public speaker and orator. He was a regular contributor to *The Irish Volunteer*, the newspaper of the Irish Volunteer movement, and in its first issue contributed a marching song based on the traditional ballad '*Óró, sé do bheatha abhaile*', which he entitled '*An Dórd Feine*' (The Fenian Chant). At Roger Casement's suggestion he set it to the tune of a traditional Jacobite march, '*Searlas Óg*' (Young Charles).

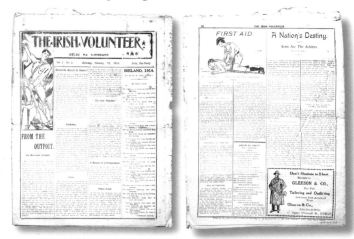

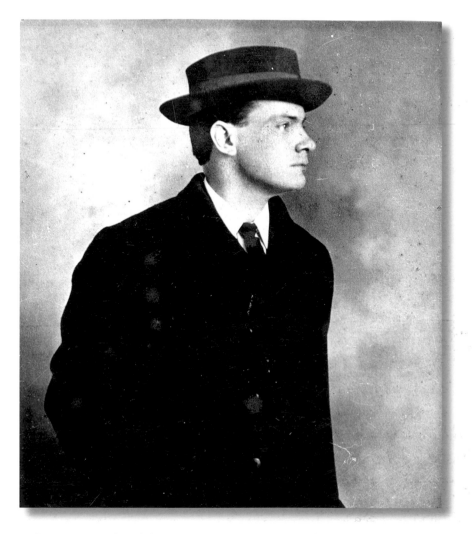

Despite his various fund-raising initiatives, Pearse's financial difficulties at Scoil Éanna continued. At the end of 1913 he turned to Bulmer Hobson, a leading member of the IRB, for assistance in arranging a fund-raising tour of the United States. Hobson was able to use his contacts with Irish-American republicans like John Devoy and the Clan na Gael organisation to secure venues and meetings with wealthy potential donors for Pearse.

Hobson was anxious to swear Pearse in as a member of the IRB. Pearse was an influential figure in many spheres of Irish life and a leading member of the Irish Volunteers, which the IRB was determined to control. Pearse agreed to join the organisation shortly before his departure for the United States. (Image courtesy of Kilmainham Gaol/OPW)

On 8 February 1914 Pearse set sail from Cobh to the United States. He wrote this typically brief postcard to his mother before departing on the SS *Campania*.

Pearse quickly realised that Irish-American audiences were more interested in hearing about the newly formed Irish Volunteers than his ideas on education. This ticket from a lecture Pearse gave in Philadelphia reflects his attempt to publicise the work of Scoil Éanna while at the same time feeding the curiosity of Irish-Americans about the new Volunteer movement. On this occasion he shared the podium with Bulmer Hobson. Pearse spoke with enthusiasm and passion about the political changes taking place in Ireland at the time.

His lectures also reflected his increasingly militant attitude towards Ireland's future. At the Emmet Commemoration in the Academy of Music in Brooklyn on 2 March 1914, he announced to the audience that the men of Ireland had 'discovered that they share a common patriotism, that their faith is one and that there is one service in which they can come together at last: the service of their country in arms'.

Reference: Patrick Pearse, *The Complete Works of P.H. Pearse: Political Writings and Speeches*, p. 73

Pearse had his silhouette drawn on a visit to the Woolworth building, which was then the tallest building in the world.

The main purpose of Pearse's American visit was to raise funds to keep Scoil Éanna afloat. This telegram from 14 March 1914 informed his family that he had cabled £200 to the bank. The most significant fund-raiser was the St Enda's Field Day held in Celtic Park, New York, on 19 April, the 800th anniversary of Brian Boru's victory at Clontarf. In addition to marching bands and Irish dancing, there was an exhibition football match between Kildare and Cavan, and a hurling match between Cork and Kilkenny. Overall the American trip raised a much-needed £1,000 for the school.

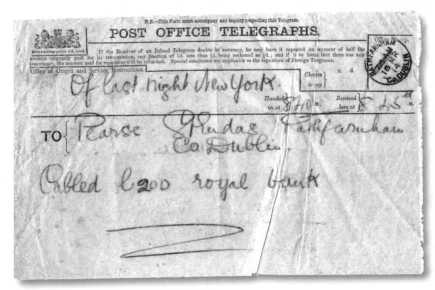

Pearse returned to Ireland on the SS *Baltic*. On his way back he wrote to Miss McKenna, whose family he had stayed with while in New York. He mentions a new pupil, Eugene Cronin, who was returning with him from the United States to be educated in St Enda's. He also thanks Miss McKenna for the hospitality she and her family had shown him: 'I feel that I owe a great debt of gratitude to you all, and especially to yourself, for all your kindness to me during my stay. I am not a very sociable or talkative person, but I did feel intimate and at home in your circle …'

Pearse was energised and inspired by his visit to the United States and those he met there. The Irish-Americans, like John Devoy and Joe McGarrity, were militant and vocal in their commitment to Irish republicanism, and their uncompromising vision appealed to Pearse. He returned to Ireland firmly committed to pursuing a radical path to achieve Irish independence.

Reference: Letter to Miss McKenna from P. H. Pearse, 14 May 1914 (2004.0036.01), Pearse Museum Collection

The success of the UVF in arming themselves made obtaining arms for the Irish Volunteers an imperative. On 26 July Erskine Childers, his wife, Molly, and Mary Spring Rice landed arms purchased in Germany in Howth, just north of Dublin city. Although this was done in broad daylight, the arms were quickly hidden to avoid being confiscated. Some of the ammunition was hidden in Scoil Éanna and when a further 600 rifles were landed in Kilcoole, County Wicklow, the school was used as the collection and distribution point for the arms. (Image courtesy of Kilmainham Gaol/OPW)

Following the outbreak of the First World War, John Redmond pledged the support of the Irish Volunteers for the British war effort. This led to a split in the movement, with the vast majority of the members following Redmond to form a new organisation, the National Volunteers. The remaining 10,000–15,000 men retained the title of Irish Volunteers. Freed from Redmond's control, the Irish Volunteers began to express increasingly radical and separatist sentiments. While the size of the organisation was smaller, Pearse's influence and status within it increased and he became press secretary and later director of military operations.

The Irish Volunteers actively campaigned against British Army recruitment for the war effort. In November 1914 Pearse was invited by the Trinity College Gaelic Society to speak alongside Yeats and Thomas Kettle at a commemoration of the birth of Thomas Davis which was to take place in the college. The Vice Provost of Trinity, Professor Mahaffy (*pictured*), banned the meeting when he heard that 'a man called Pearse' was to be in attendance. The meeting took place outside the college and Pearse spoke as planned, further enhancing his reputation as the public face of Irish radicalism.

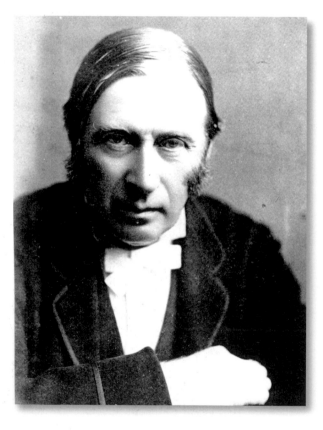

As his status within the Volunteers grew, so too did his position within the IRB. The departure of Redmond and his followers also gave the IRB an opportunity to thoroughly infiltrate the Volunteer movement and put their members in key positions. Pearse had been a member of the IRB since before his American visit, but it was only in 1915 that he was invited to join their Supreme Council.

The political tensions around Home Rule, the foundation of the UVF and IVF, and the outbreak of the First World War resulted in an increased militarisation of many aspects of Irish life. Military uniforms were increasingly visible and the sight of men and women marching and drilling became common.

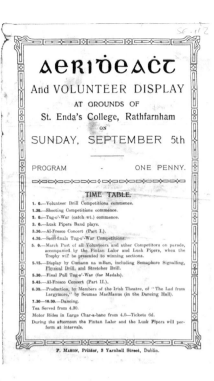

Given Pearse's leading role in the Irish Volunteers and, covertly, in the IRB, it is not surprising that life in Scoil Éanna took on an increasingly martial tone. The annual Aeridheacht held on 5 September 1915 was billed alongside a Volunteer display. While there were still plays, songs and recitations, the large-scale pageants and plays performed by the pupils in the past were largely replaced by drill displays and marching bands.

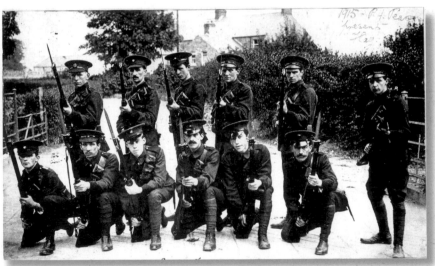

A Company, 4th Battalion of the Dublin Brigade of the Volunteers (*pictured*) won a trophy at the Aeridheacht in 1915 and were presented with a flag by Pearse. The grounds of Scoil Éanna were an important centre for training and drilling of the Irish Volunteers. Its secluded location also made it a useful location for secret meetings in the days and months leading up to the 1916 Rising.

The pupils of Scoil Éanna would have been aware of the military training and manoeuvres taking place in the grounds of their school. In this edition of the boys' own magazine, *An Scoláire*, from 20 April 1913, they depict a drill by 'Our Sunday Visitors', that is members of Fianna Éireann, a youth organisation for Irish separatists founded in 1909 by Bulmer Hobson and Countess Markievicz as an 'Irish Ireland' alternative to Baden-Powell's Boy Scouts.

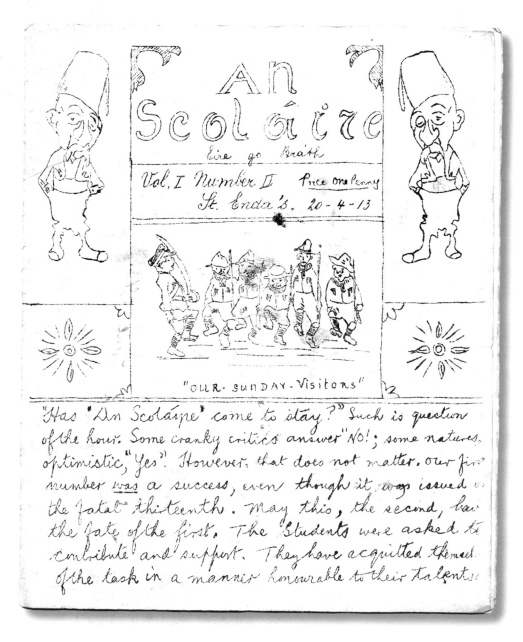

An

Scoláire

éire go brách

Vol. I Number II Price one Penny

St. Enda's. 20 - 4 - 13

"OUR - SUNDAY - VISITORS"

"Has 'An Scoláire' come to stay?" Such is question of the hour. Some cranky critics answer "NO!"; some natures, optimistic, "Yes". However, that does not matter. Our first number was a success, even though it was issued on the fatal thirteenth. May this, the second, have the fate of the first. The Students were asked to contribute and support. They have acquitted themselves of the task in a manner honourable to their talents.

Con Colbert, who would later be executed for his part in the 1916 Rising, had become Physical Education master when the school moved to The Hermitage. He used the 'Swedish Method' of physical training, which laid emphasis on discipline, marching and military drill. This was in line with the guidelines issued by the Department of Education in London. They were concerned about the poor physical quality of recruits to the British Army and believed exercise and training in schools would help address this problem.

Desmond Ryan remembered Colbert standing excitedly in the Study Hall, 'eyes smouldering, taut in his green jersey as he drills the boys. Lithe and smiling he puts them through drills and exercise with sword-sticks and teaches them the semaphore alphabet and tells them he knows every part of all makes of guns.'

The semaphore cards pictured here were used in the school. They were created by Lt-Col. W. J. Younger of the 4th Royal Scots (Queen's Edinburgh Rifles) and promised to allow purchasers to learn semaphore signalling in just one week.

Colbert played a leading role in the organisation and training of Fianna Éireann and the Volunteers. He was also an important figure in the IRB. Even before Pearse was sworn into the IRB, Colbert had already recruited several of his former pupils, including Eamonn Bulfin, Joseph Sweeney, Desmond Ryan and Frank Burke, into that society.

Reference: Desmond Ryan, *Remembering Sion: A Chronicle of Storm and Quiet*, p. 166

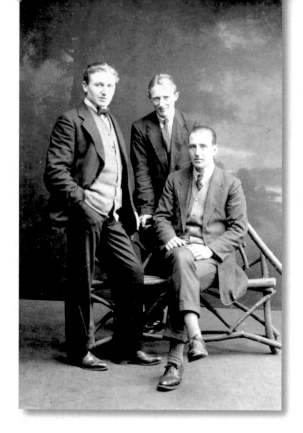

Joseph Sweeney (*middle*) and Eamonn Bulfin (*seated*) were both secretly sworn into the IRB without Pearse's knowledge.

The passing of Jeremiah O'Donovan Rossa presented an opportunity for the IRB and other Irish separatist groups to rally support for their cause. He had been part of the Fenian Plot in the 1860s and was arrested and imprisoned in Britain. He was released in 1870 as part of the 'Fenian Amnesty', on condition that he go into voluntary exile in the United States. He continued to agitate for Irish independence until his death on 29 June 1915. The Irish Volunteers, Irish Citizen Army and other nationalist organisations came together to plan a massive public funeral on 1 August. Behind the scenes, however, it was the IRB, under the direction of Thomas Clarke, who secretly drove and controlled the event. (Image courtesy of Kilmainham Gaol/OPW)

Clarke (pictured here with O'Donovan Rossa's daughter Eileen) made sure that IRB members held key positions on each of the organising sub-committees and it was he who decided that Pearse should deliver the graveside oration. Although Pearse had gained a reputation as an impressive orator and speechwriter, he turned to Clarke for advice about how far he should go in his speech. Clarke replied that he should go 'as far as you can. Make it as hot as hell, throw all discretion to the winds.'

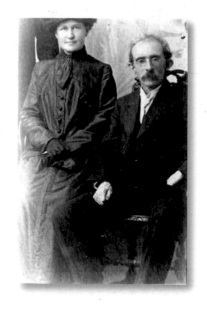

Pearse did not disappoint. (Image courtesy of Kilmainham Gaol/OPW)

Reference: Ruth Dudley Edwards, *Patrick Pearse: The Triumph of Failure*, p. 235

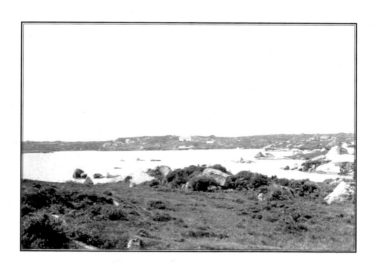

Pearse retreated to his cottage in Rosmuc to prepare the oration. He was joined by his ever faithful brother Willie, and Desmond Ryan, his secretary and a former pupil at Scoil Éanna. In the solitude and beauty of Connemara he wrote the speech which was to confirm him as the face and voice of the coming revolution.

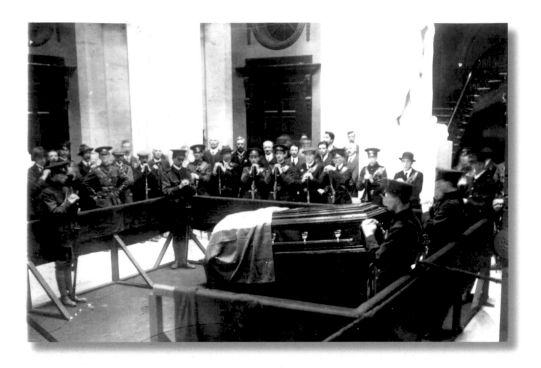

Following the established tradition for public political funerals in Dublin, the body of O'Donovan Rossa first lay in state in City Hall. It then travelled to the cemetery in Glasnevin in a massive funeral procession, which was led by the Irish Volunteers and Irish Citizen Army. The funeral cortège leaving City Hall can be seen below.

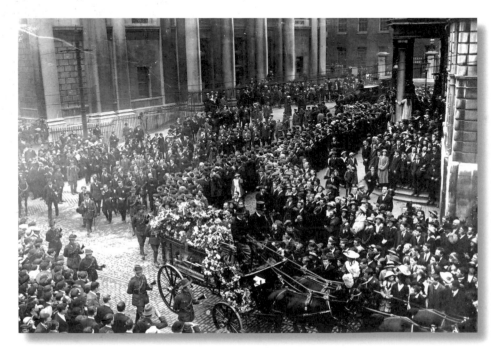

The funeral drew thousands of spectators and access to the graveside was restricted to those who had been issued with special passes like this.

O'Donovan Rossa Funeral Committee.

GLASNEVIN CEMETERY.

PASS TO GRAVE SIDE

Wolfe Tone Memorial Association.

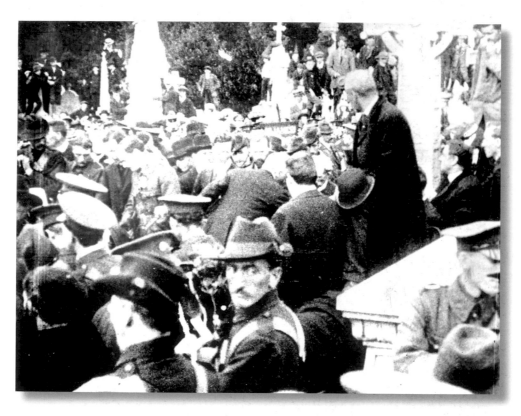

Pearse can be clearly identified towards the left of this photograph, which shows him just before he made his historic speech. The image is a still taken from an early news reel that was made of the event and is the only image of Pearse on film.

Pearse was known to record himself practising his speeches on a wax cylinder phonograph. The whereabouts of these recordings are unknown.

This is the first page of the manuscript of Pearse's oration. He began by presenting himself as one speaking on behalf of a new generation that had been re-baptised in the Fenian faith. He spoke in characteristically quasi-religious terms of the holiness and simplicity of patriotism, building up to a climactic final paragraph in which he rallied his audience with an unambiguous call for defiance against British rule in Ireland:

> Life springs from death; and from the graves of patriot men and women spring living nations. The Defenders of the Realm have worked well in secret and in the open. They think that they have pacified Ireland. They think that they have purchased half of us and intimidated the other half. They think they have forseen everything, think that they have provided against everything; but the fools, the fools the fools! – they have left us our Fenian dead, and while Ireland holds these graves, Ireland unfree shall never be at peace.

Pearse had more than lived up to the task given to him. His words electrified his listeners and it remains one of the most famous Irish political speeches. Desmond Ryan, who stood amongst that crowd, wrote about that day:

> Beside the grave he stood, impressive and austere in green, with slow and intense delivery, and as he cried aloud upon the fools he threw back his head sharply and the expression seemed to vivify the speech which ended calmly and proudly. He walked home alone, and sat in his study: at last he had spoken the just word he sought to immortalise a man less great than himself [sic].

References: Patrick Pearse, *The Complete Works of P.H. Pearse: Political Writings and Speeches*, pp. 136–7; Desmond Ryan, *Remembering Sion: A Chronicle of Storm and Quiet*, p. 193

The last of Pearse's plays to be performed during his lifetime, in May 1915, was *The Master*. It was produced in The Irish Theatre on Hardwicke Street. The theatre was founded in 1915 by Edward Martyn, Joseph Plunkett and Thomas MacDonagh to offer an alternative to the Abbey Theatre and what they saw as its preoccupation with 'peasant plays'. The Irish Theatre took a much more radical approach and offered plays in both Irish and English, as well as translations of plays by European playwrights like Ibsen and Strindberg.

The Master is set in early Christian Ireland and centres around the conflict between two opposing figures: Ciarán, a monk, and a king, Daire. Ciarán has converted to Christianity, retreating to the wilderness in search of enlightenment. His reputation attracts pupils to his monastery, but he is forbidden to teach and challenge the old ways of the Druids by Daire. Daire challenges Ciarán's God to make himself manifest and prove his existence, by threatening to kill Iollan, an innocent child. The play concludes when the Archangel Michael appears to defend Iollan.

The conflicts that the play explores echo many of those in Pearse's personality at the time. Ciarán, the spiritual teacher who rejects the material world, has obvious parallels with Pearse's own aspirations. However, Daire also reveals himself to be concerned with all the souls of this nation, born and unborn. His path of leadership and action is not presented as any less worthy than Ciarán's.

The role of Ciarán was played by Willie Pearse, and many of the other players were former students of Scoil Éanna who continued to live on in the school while at university.

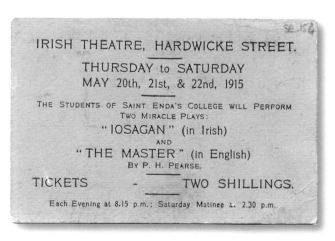

IRISH THEATRE, HARDWICKE STREET.

THURSDAY to SATURDAY
MAY 20th, 21st, & 22nd, 1915

THE STUDENTS OF SAINT ENDA'S COLLEGE WILL PERFORM
TWO MIRACLE PLAYS:

"IOSAGAN" (in Irish)
AND
"THE MASTER" (in English)
BY P. H. PEARSE.

TICKETS - TWO SHILLINGS.

Each Evening at 8.15 p.m.; Saturday Matinee at 2.30 p.m.

Nearly all of the cast would later fight in the 1916 Rising.

Pearse's final play, *The Singer*, was completed in late 1915. It tells the story of MacDara, a charismatic and mystical figure from the west of Ireland who eventually leads a rebellion against British rule. A planned production in the Abbey Theatre in 1916 was cancelled for fear it would reveal too much about the plans for the Rising.

Whatever the parallels between real events and those described by Pearse, *The Singer* is primarily a representation of Pearse's ideal of a rebellion, and MacDara, the orator, teacher and leader of men, can be read as Pearse's ideal self. The play climaxes with an act of self-sacrifice by MacDara as he faces into battle alone. In his final speech he declaims: 'One man can free a people as one man redeemed the world. I will take no pike, I will go into battle with bare hands. I will stand up before the Gall as Christ hung naked before men on the tree!'

The first performance did not take place until 1917, when it was performed by a cast which included many of Pearse's former pupils who had fought alongside him in the Rising.

References: Patrick Pearse, *The Complete Works of P.H. Pearse: Poems, Plays, Stories,* p. 44

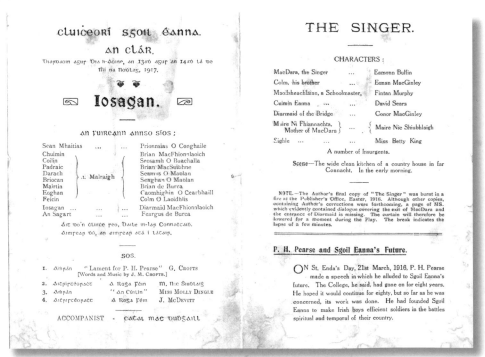

With plans for a rebellion in 1916 in place, Pearse was determined to leave behind a written political legacy. Despite the enormous pressures on his time and energies, in the months leading up to the Rising he released a flurry of publications, both literary and political. *An Mháthair agus Scéalta Eile* (*The Mother and Other Stories*) was a collection of new and previously published short stories. He also managed to produce a quartet of political pamphlets between Christmas 1915 and 31 March 1916 – *Ghosts*, *The Separatist Idea*, *The Spiritual Nation* and *The Sovereign People*. Throughout the course of these essays he identifies the four evangelists of Irish separatism – Theobald Wolfe Tone, Thomas Davis, John Mitchel and James Fintan Lalor. He chose them because they had left behind a body of teaching that could be used as a guide for future generations. Pearse saw their writings as an articulation of the Irish separatist tradition which offered both a precedent and a justification for the use of armed insurrection to achieve independence. In his essays Pearse seeks the benediction of past generations for his plans for revolution, while at the same time setting out a vision of Irish nationality for those who would come after him. (Images of Davis (*top left*) and Lalor (*bottom right*) courtesy of the National Library of Ireland; image of Mitchel (*top right*) courtesy of Kilmainham Gaol/OPW)

Pearse was the most publicly vocal of all the extreme separatists and his skills as an orator meant he was in constant demand as a public speaker. He increasingly appeared in his Irish Volunteer uniform and was unambiguously militant in his attitude. In this picture he can be seen in his uniform addressing a large crowd in Dolphin's Barn in Dublin in August 1915.

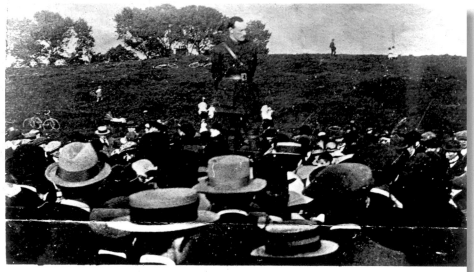

P. H. Pearse Speaking at Dolphin's Barn, August 30th, 1915.

This receipt is from the Hotel Metropole in Waterford and was issued to Mr Pearse on 14 February 1916. Pearse was in Waterford to give a lecture entitled 'Nationality' at the Town Hall at the invitation of the Gaelic League.

Pearse's work in inspiring support for the Volunteers and covertly preparing the population for the coming revolution was seen as vital to its ultimate success by his fellow revolutionaries. As a teacher and scholar, Pearse provided a respectable public face for the movement.

In response to the attacks on striking workers during the 1913 Lockout, a socialist military organisation called the Irish Citizen Army had been founded. Pearse and his colleagues in the IRB became aware that the socialist leader, James Connolly, had his own plans for a revolution. Fearful that it would upset their plans, they managed to persuade him to combine his organisation's effort with theirs and mount a joint rebellion.

While Pearse opposed Irish participation in the British Army in the First World War, he wrote enthusiastically about the war as a chance for heroic action. Like many European commentators at the time, Pearse celebrated the opportunity war presented

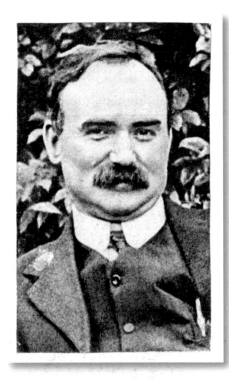

for men to fight and die for their country. He articulated his views in a short article entitled 'Peace and the Gael', which he published anonymously in *The Spark* in December 1915. In it he claimed that the 'last sixteen months have been the most glorious in the history of Europe. Heroism has come back to the earth.' He goes on to say that it 'is good for the world that such things should be done. The old heart of the earth needed to be warmed with the red wine of the battlefields. Such august homage was never before offered to God as this, the homage of millions of lives given gladly for love of country.'

'Peace and the Gael' remains one of Pearse's most controversial pieces of writing and is seen by many as evidence of his fascination with blood sacrifice and martyrdom. James Connolly was indignant when he read the article and published a rebuttal in the *Irish Worker*: 'No, we do not think that the old heart of the earth needs to be warmed with the red wine of millions of lives. We think anyone who does is a blithering idiot. We are sick of such teaching, and the world is sick of such teaching.' (Image courtesy of Kilmainham Gaol/OPW)

References: Patrick Pearse, *The Complete Works of P.H. Pearse: Political Writings and Speeches*, p. 216; Ruth Dudley Edwards, *Patrick Pearse: The Triumph of Failure*, p. 245

The final lines of Pearse's poem 'Christmas 1915' makes an unambiguous reference to the coming rebellion: 'In the coming battle, Help the Gael!'

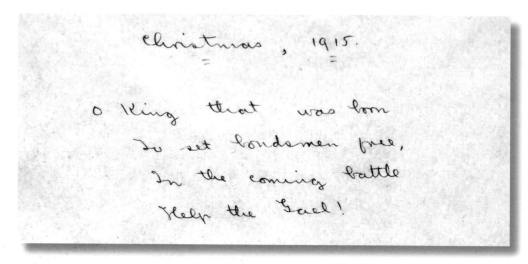

Secret plans were made for the rebellion to take place on Easter Sunday 1916. The Volunteers countrywide were to be assembled under the guise of carrying out routine manoeuvres on Easter Sunday. Pearse's mobilisation order for the Rathfarnham-based E Company issued on Holy Thursday, which required the men to bring all their arms and ammunition with them, may have alerted some members that Easter Sunday would be more than just a drill. (Image courtesy of Kilmainham Gaol/OPW)

While the ordinary members were not aware that an uprising was to take place, the members of the Volunteers living in St Enda's were part of the inner circle and had been preparing for an insurrection for months. They experimented with making home-made bombs and incendiary devices in the basement with the assistance of one of the Chemistry masters, Peter Slattery.

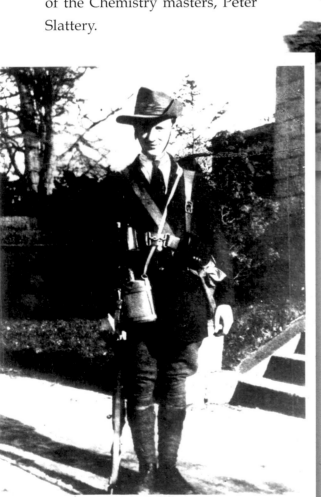

With rebellion in the air, Joseph Sweeney and an Irish-American former pupil, John Kilgallon, photographed each other in their Volunteer uniforms (Sweeney is full face, Kilgallon in profile).

JOHN
MACNEILL

Eoin MacNeill was one of Pearse's oldest friends and a colleague from the Gaelic League. He was also Chief of Staff of the Volunteers, but was kept in the dark about the plans for the rebellion and only found out about them on Wednesday 19 April. Initially he agreed to support the rebellion, but once he discovered the fate of the *Aud*, the ship carrying German arms that was scuttled to avoid capture by the British, and that no further aid would be forthcoming from Germany, he issued an order cancelling all Easter Sunday manoeuvres. Pearse quickly issued a countermanding order, informing Volunteer commanders that these manoeuvres had merely been postponed to the following day. The confusion that followed meant that the majority of the Volunteers throughout the country failed to act on Easter Monday. (Image courtesy of the National Library of Ireland)

On Easter Sunday the Scoil Éanna graduates posed for a photo in the grounds of the school with their rifles provocatively raised.

Standing (left to right): Eamonn Bulfin, Conor McGinley, Desmond Ryan and Fintan Murphy (on the far right is teacher Peter Slattery).

Kneeling: Brian Joyce, Frank Burke, Eunan McGinley and Joseph Sweeney.

In 1967 the surviving members of the group who posed for this photo gathered in Scoil Éanna and re-posed the photo. Their former teacher, Peter Slattery, had died in the intervening years, as had Eunan McGinley. He was the youngest of the group, but was killed in a motorcycle crash in 1923.

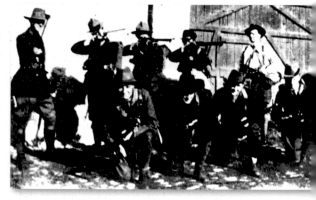

These ordinary, chipped cups and saucers were used by the Pearse brothers at their last family meal in Scoil Éanna. For their mother and sisters they acted as a physical link to their last private moment together before their lives were torn apart.

Years later, Margaret Pearse described her final farewell to her brother:

After tea and a little talk they both arranged to leave us again. As they were passing through the front hall Pat suddenly turned back and went down the stairs again. Mother said, 'Did you forget something?' He said, 'I did.' He came back and either Mother or I asked him, 'Did you get it?' – I do not know what it was that he had forgotten – his answer was 'I did.' Those were the last words I ever heard him speak.

Reference: Margaret Pearse, 'The Last Days of Pat and Willie Pearse at St. Enda's', in *Leabharán Cuimhneacháin arna Fhoilsiú ar Ócáid Bronnadh Eochar Scoil Éanna ar Uachtarán na hÉireann Eamon De Valera 23 Aibreán 1970*, p. 39

THE RISING

POBLACHT NA H EIREANN.

THE PROVISIONAL GOVERNMENT

OF THE

IRISH REPUBLIC

TO THE PEOPLE OF IRELAND.

IRISHMEN AND IRISHWOMEN: In the name of God and of the dead generations from which she receives her old tradition of nationhood, Ireland, through us, summons her children to her flag and strikes for her freedom.

Having organised and trained her manhood through her secret revolutionary organisation, the Irish Republican Brotherhood, and through her open military organisations, the Irish Volunteers and the Irish Citizen Army, having patiently perfected her discipline, having resolutely waited for the right moment to reveal itself, she now seizes that moment, and, supported by her exiled children in America and by gallant allies in Europe, but relying in the first on her own strength, she strikes in full confidence of victory.

We declare the right of the people of Ireland to the ownership of Ireland, and to the unfettered control of Irish destinies, to be sovereign and indefeasible. The long usurpation of that right by a foreign people and government has not extinguished the right, nor can it ever be extinguished except by the destruction of the Irish people. In every generation the Irish people have asserted their right to national freedom and sovereignty; six times during the past three hundred years they have asserted it in arms. Standing on that fundamental right and again asserting it in arms in the face of the world, we hereby proclaim the Irish Republic as a Sovereign Independent State, and we pledge our lives and the lives of our comrades-in-arms to the cause of its freedom, of its welfare, and of its exaltation among the nations.

The Irish Republic is entitled to, and hereby claims, the allegiance of every Irishman and Irishwoman. The Republic guarantees religious and civil liberty, equal rights and equal opportunities to all its citizens, and declares its resolve to pursue the happiness and prosperity of the whole nation and of all its parts, cherishing all the children of the nation equally, and oblivious of the differences carefully fostered by an alien government, which have divided a minority from the majority in the past.

Until our arms have brought the opportune moment for the establishment of a permanent National Government, representative of the whole people of Ireland and elected by the suffrages of all her men and women, the Provisional Government, hereby constituted, will administer the civil and military affairs of the Republic in trust for the people.

We place the cause of the Irish Republic under the protection of the Most High God, Whose blessing we invoke upon our arms, and we pray that no one who serves that cause will dishonour it by cowardice, inhumanity, or rapine. In this supreme hour the Irish nation must, by its valour and discipline and by the readiness of its children to sacrifice themselves for the common good, prove itself worthy of the august destiny to which it is called.

Signed on Behalf of the Provisional Government,

THOMAS J. CLARKE.

SEAN Mac DIARMADA, THOMAS MacDONAGH.

P. H. PEARSE, EAMONN CEANNT,

JAMES CONNOLLY. JOSEPH PLUNKETT.

Pearse was the figurehead and public face of the Rising as commander-in-chief and president of the Republic. In that role he read the proclamation of the Irish Republic on the steps of the General Post Office on Easter Monday morning.

While the Proclamation represented the collective views of its seven signatories, Pearse's writing style is clearly evident in its composition and it is likely that he and James Connolly were its principal authors. (Image courtesy of Kilmainham Gaol/OPW)

Pearse's sister, Mary Brigid, was in the city on Easter Monday. She is said to have gone to Liberty Hall where the Volunteers and Irish Citizen Army were assembling in advance of the Rising. She begged Pearse to go home saying, 'Come home, Pat, and leave all this foolishness!' Ignoring her pleas, Pearse took his place at the front of his men and marched to the GPO.

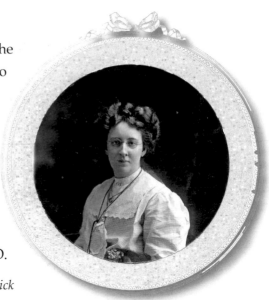

Reference: Ruth Dudley Edwards, *Patrick Pearse: The Triumph of Failure*, p. 235

Pearse was based in the headquarters of the Rising in the GPO for most of the week, as were many of the former Scoil Éanna pupils and other members of the Rathfarnham branch of the Volunteers. Willie served as his aide-de-camp and spent much of the rebellion by his side.

Pearse was not a skilled military tactician and the direction of the fighting was largely carried out by men like James Connolly and Joseph Plunkett. Pearse's main contribution was in raising morale and issuing propaganda to bolster support. A newspaper entitled *Irish War News* was issued on the Tuesday of the rebellion and Pearse contributed a communiqué which exaggerated the success of the rebels in securing the city and the growing numbers swelling their ranks. (Image courtesy of Kilmainham Gaol/OPW)

IRISH WAR NEWS

THE IRISH REPUBLIC.

Vol. 1. No. 1 DUBLIN, TUESDAY, APRIL 25, 1916. One Penny

"IF THE GERMANS CONQUERED ENGLAND."

In the London "New Statesman" for *April 1st*, an article is published—"If the Germans Conquered England," which has the appearance of a very clever piece of satire written by an Irishman. The writer draws a picture of England under German rule, almost every detail of which exactly fits the case of Ireland at the present day. Some of the sentences are so exquisitely appropriate that it is impossible to believe that the writer had not Ireland in his mind when he wrote them. For instance :—

"England would be constantly irritated by the lofty moral utterances of German statesmen who would assert—quite sincerely, no doubt—that England was free, freer indeed than she had ever been before. Prussian freedom, they would explain, was the only real freedom, and therefore England was free. They would point to the flourishing railways and farms and colleges. They would possibly point to the contingent of M.P's, which was permitted, in spite of its deplorable disorderliness, to sit in a permanent minority in the Reich-

stag. And not only would the Englishman have to listen to a constant flow of speeches of this sort ; he would find a respectable official Press secret bought over by the Government to say the same kind of things over and over, every day of the week. He would find, too, that his children were coming home from school with new ideas of history. . . . They would ask him if it was true that until the Germans came England had been an unruly country, constantly engaged in civil war. . . . The object of every schoolbook would be to make the English child grow up in the notion that the history of his country was a thing to forget, and that the one bright spot in it was the fact that it had been conquered by cultured Germ ny."

"If there was a revolt, German statesmen would deliver grave speeches about "disloyalty," "ingratitude," "reckless agitators who would ruin their country's prosperity. . . . Prussian soldiers would be encamped in every barracks—the English conscripts having been sent out of the country to be trained in Germany, or to fight the Chinese—in order to come to the aid of German morality, should English sedition come to blows with it."

"England would be exhorted to abandon her own genius in order to imitate the genius of her conquerors, to forget her own history for a larger history, to give up her own language for a "universal" language—in other words, to destroy her household gods one by one, and put in their place

The British forces had been taken by surprise on Easter Monday, but by Wednesday they had begun to retaliate in earnest. The gunship *Helga* sailed up the Liffey and began to bombard the rebel positions. Pearse watched as the city he had lived his whole life in went up in flames. He turned to his secretary, Desmond Ryan, saying, 'When we are all wiped out, people will blame us for everything, condemn us. But for this protest, the war would have ended & nothing would have been done. After a few years they will see the meaning of what we have tried to do.'

Troops poured into the city and fires raged around Sackville Street, forcing the rebels to abandon the GPO on Friday evening. James Connolly

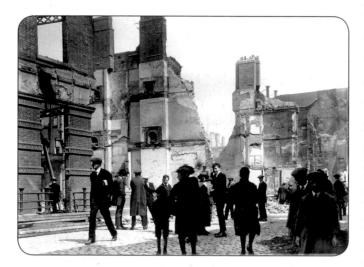

had been badly wounded and had to be removed on a stretcher. Patrick and Willie were among the last to leave. They found shelter and relative safety in Cogan's Grocery Store, where Mrs Cogan provided them with food.

Reference: Joost Augusteijn, *Patrick Pearse: The Making of a Revolutionary*, p. 316

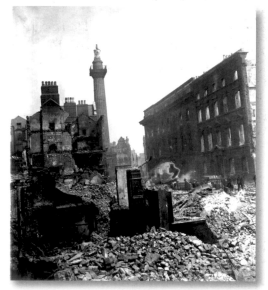

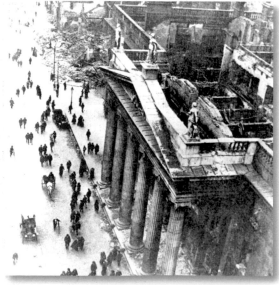

The men attempted to tunnel through the houses in Moore Street to a slightly more secure position. It was in 16 Moore Street, on the morning of Saturday 29 April, that Pearse, Connolly, Thomas Clarke, Seán MacDiarmada and Joseph Plunkett decided to surrender. Nurse Elizabeth O'Farrell was given a white flag and nervously walked up Moore Street to the British Army barricade on Great Britain (now Parnell) Street with a message for the Dublin commander, Brigadier General Lowe, seeking a meeting to discuss the terms of surrender. She was taken to Thomas Clarke's tobacconist shop where she

met Lowe. He gave her a note for Pearse in which he said he was willing to 'receive you in Britain Street at the north end of Moore Street provided that you surrender unconditionally. You will proceed up Moore Street accompanied only by the woman who brings you this note under a white flag.' (Images courtesy of Kilmainham Gaol/OPW)

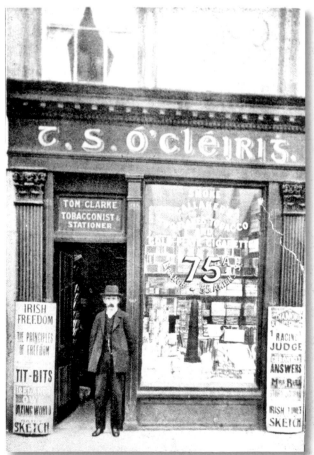

Reference: Ruth Dudley Edwards, *Patrick Pearse: The Triumph of Failure*, p. 306

Willie Pearse borrowed a safety razor so that Patrick, scrupulous as always about his personal appearance, could be clean-shaven when meeting with the enemy forces. Before leaving he bade farewell to his comrades, including Willie. The two brothers never saw each other again.

Pearse and Nurse O'Farrell walked together to the top of Moore Street, where they met with General Lowe. Pearse handed over his pistol, sword and canteen, which contained two large onions. The following year Elizabeth O'Farrell described the conversation between Lowe and Pearse in *The Catholic Bulletin*:

> Gen. Lowe to Com. Pearse: 'The only condition I make is that I will allow the other commandants to surrender. I understand you have the Countess de Markievicz down there.'
>
> Com. Pearse: 'No, she is not with me.'
>
> Gen. Lowe: 'Oh I know she is down there.'
>
> Com. Pearse: 'Don't accuse me of speaking an untruth.'
>
> Gen Lowe: 'Oh I beg your pardon Mr. Pearse but I know she is in the area.'
>
> Com. Pearse: 'Well she is not with me sir.'
>
> … After this he was taken away in a motor car, down O'Connell Street, accompanied by Gen. Lowe's son and another officer inside.

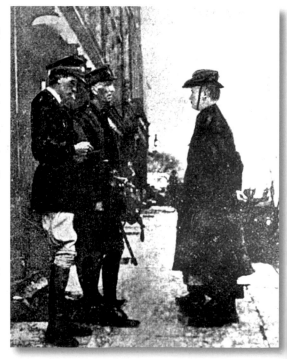

The image shows the surrender of Pearse to Brigadier-General Lowe. Lowe's son John stands beside him – he later became a Hollywood actor under the name John Loder. Elizabeth O'Farrell stood back out of the shot – only her feet can be seen. This is the last photograph ever taken of Pearse. (Image courtesy of Kilmainham Gaol/ OPW)

Reference: *The Catholic Bulletin and Book Review*, Vol. VII, No. 4, April 1917, p. 269

Pearse was brought to Parkgate Barracks and interviewed by Sir John Maxwell, British commander-in-chief. Following this he wrote a surrender note ordering the commandants of the rebel outposts to lay down their arms.

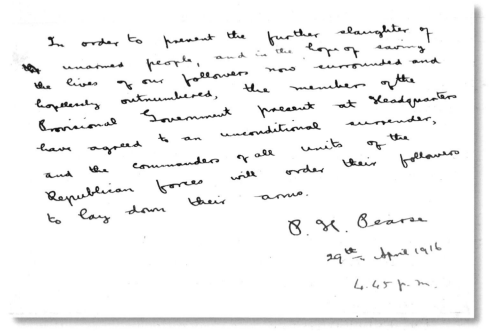

Pearse was then moved to Arbour Hill Barracks. From his cell there he wrote to his mother on 1 May, 'People will say hard things of us now, but we shall be remembered by posterity and blessed by unborn generations.'

Pearse also composed a final series of poems. Pearse's mother later described the background to the poems he had written for her in Arbour Hill. One evening just prior to the Rising she came to him and said, 'if you go there will be no one to write something for me – as your father used to. He wrote such beautiful things when your Auntie Kate and Grandfather died. Do you think you – could write something for me? If you – get time?'

To My Mother

My gift to you hath been the gift of sorrow,
My one return for your rich gifts to me,
Your gift of life, your gift of love and pity,
Your gift of sanity, your gift of faith

(For who hath had such faith as yours
Since the old time, and what were my poor faith
Without your strong belief to found upon?)
For all these precious things my gift to you
Is sorrow. I have seen
Your dear face line, your face soft to my touch,
Familiar to my hands and to my lips
Since I was little:
I have seen
How you have battled with your tears for me,
And with a proud glad look, although your
 heart
Was breaking. O Mother (for you know me)
You must have known, when I was silent,
That some strange thing within me kept me dumb,
Some strange deep thing, when I should shout my love?
I have sobbed in secret
For that reserve which yet I could not master.
I would have brought royal gifts, and I have brought you
Sorrow and tears: and yet, it may be
That I have brought you something else besides –
The memory of my deed and of my name
A splendid thing which shall not pass away.
When men speak of me, in praise or in dispraise,
You will not heed, but treasure your own memory
Of your first son.

The other poem Pearse wrote for his mother, 'A Mother Speaks', makes an overt connection between Mrs Pearse's plight and that of the Virgin Mary. It reflects Pearse's own identification with the self-sacrifice of Christ, which is increasingly evident in his writings in the years leading up to the Rising. The religious quality of his poems had a significant effect on his public portrayal after the Rising, as evidenced by the near-contemporary image of him beholding an apparition of the Virgin Mary in his prison cell on the page opposite.

A Mother Speaks

Dear Mary, that didst see thy first-
 born Son
Go forth to die amid the scorn of
 men
For whom He died,
Receive my first-born son into thy
 arms,
Who also hath gone out to die for
 men,
And keep him by thee till I come
 to him.
Dear Mary, I have shared thy sorrow,
And soon shall share thy joy.

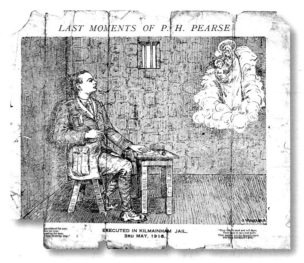

LAST MOMENTS OF P. H. PEARSE

EXECUTED IN KILMAINHAM JAIL,
3RD MAY, 1916.

Pearse also wrote a poem for Willie.

To My Brother

O faithful!
Moulded in one womb,
We have stood together all the years,
All the glad years and all the sorrowful years,
Own brothers: through good repute and ill,
In direst peril true to me,
Leaving all things for me, spending yourself
In the hard service that I taught to you,
Of all the men that I have known on earth,
You only have been my familiar friend,
Nor needed I another.

References: Mary Brigid Pearse (ed.), *The Home-Life of Pádraig Pearse*, p. 51; Piarais MacLochlainn, *Last Words, Letters and Statements of the Leaders Executed After the Rising at Easter 1916*, pp. 5–35

It would seem that Patrick may never have known that his brother was also to be executed. In his last letter to his mother, written in the early hours of 3 May, Pearse wrote, 'I hope and believe that Willie and the St. Enda's Boys will be safe.'

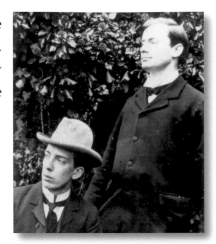

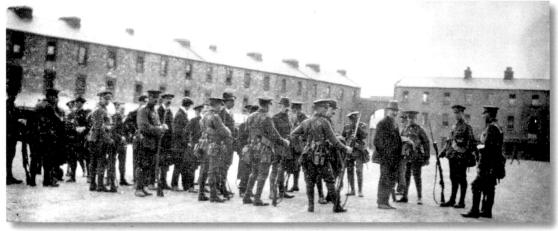

Richmond Barracks (*pictured*) was the location for Pearse's court martial on 2 May. In a statement to the court he said:

> I am one of the persons responsible, have acted as C-in-C and president of the provisional Government. I am prepared to take the consequences of my act, but I should like my followers to receive an amnesty. I went down on my knees as a child and told God I would work all my life to gain the freedom of Ireland.

Pearse was found guilty of treason and sentenced to death by firing squad.

References: Piarais MacLochlainn, *Last Words, Letters and Statements of the Leaders Executed After the Rising at Easter 1916*, pp. 5–35; Brian Barton, *From Behind a Closed Door: Secret Court Martial Records of the 1916 Rising*, p. 117

Following his court martial Pearse was transferred to Kilmainham Gaol, where he awaited his execution. None of his family were able to visit him. It is believed that he composed his final poem, 'The Wayfarer', in his cell in Kilmainham.

THE WAYFARER

The beauty of the world hath made me sad,
This beauty that will pass;
Sometimes my heart hath shaken with great joy
To see a leaping squirrel in a tree,
Or a red lady-bird upon a stalk,
Or little rabbits in a field at evening,
Lit by a slanting sun,
Or some green hill where shadows drifted by
Some quiet hill where mountainy man hath sown
And soon would reap; near to the gate of Heaven;
Or children with bare feet upon the sands
Of some ebbed sea, or playing on the streets
Of little towns in Connacht,
Things young and happy.
And then my heart hath told me:
These will pass,
Will pass and change, will die and be no more,
Things bright and green, things young and happy;
And I have gone upon my way
Sorrowful.

In the final paragraph of his last letter to his mother Pearse wrote:

Wow-Wow [his sister Margaret], Willie, Mary Brigid, and Mother, good bye. I have not words to tell my love of you, and how my heart yearns to you all. I will call to you in my heart at the last moment.

Your son, Pat

Reference: Piarais MacLochlainn, *Last Words, Letters and Statements of the Leaders Executed After the Rising at Easter 1916*, p. 33

Fr Aloysius, a priest from the Capuchin Friary on Church Street, managed to get permission to visit Pearse and administer the last rites. This crucifix was held by Pearse and he scratched his initials in Irish, PMP, on the back. (Images courtesy of Kilmainham Gaol/OPW)

At 3.30 a.m. on the morning of 3 May 1916, Pearse was shot in the Stonebreakers' Yard of Kilmainham Gaol. Thomas Clarke and Thomas MacDonagh were executed on the same day.

Willie was able to see his mother and sister before his execution the following day. He told them about a terrible incident which had taken place the previous evening: 'Last night,' he said, 'I had a terrible experience. I was in prison over there (indicating across the road) when a guard of soldiers came and brought me here. About half way over we heard shots. The men looked at each other and said: "Too late." I think they were bringing me here to see Pat, but we heard only the volley that took him.'

Both brothers were buried, along with twelve of the other leaders, in Arbour Hill prison.

Reference: Piarais MacLochlainn, *Last Words, Letters and Statements of the Leaders Executed After the Rising at Easter 1916*, p. 79

'GHOSTS THAT WILL TAKE A LITTLE LAYING': AFTERMATH

Mrs Pearse and her daughter Margaret continued to run Scoil Éanna. In 1924 Mrs Pearse went on a fund-raising tour across the United States, where she was fêted as the mother of Patrick and Willie Pearse. This photo was taken at one of the largest events held in her honour, in San Francisco. Despite raising over $10,000, financing the school remained a challenge.

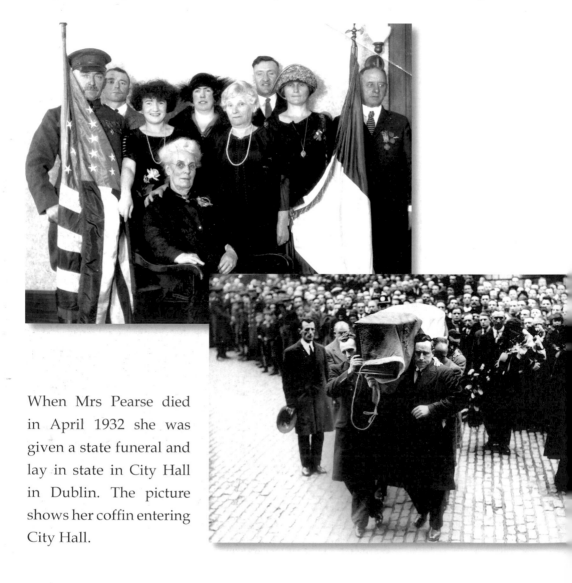

When Mrs Pearse died in April 1932 she was given a state funeral and lay in state in City Hall in Dublin. The picture shows her coffin entering City Hall.

Pearse's sister Margaret continued to run Scoil Éanna until 1935. Although she and her mother were dedicated to preserving Pearse's legacy, the school never regained the kind of energy and innovation it had had before the Rising.

In 1933 Margaret was elected to Dáil Éireann as a Fianna Fáil TD, but served only one term. Following her defeat in the 1937 election, she entered the Seanad. She remained a member of Seanad Éireann until her death in 1968.

She is pictured here, along with Éamon de Valera, at a commemoration at the grave of the 1916 leaders in Arbour Hill. Like her mother, she saw herself as the guardian of her brother's legacy.

Left to right: Liam Scarlett (grandson of Pearse's half-brother James), Margaret Pearse and Éamon de Valera. Seán Lemass is seated immediately behind them.

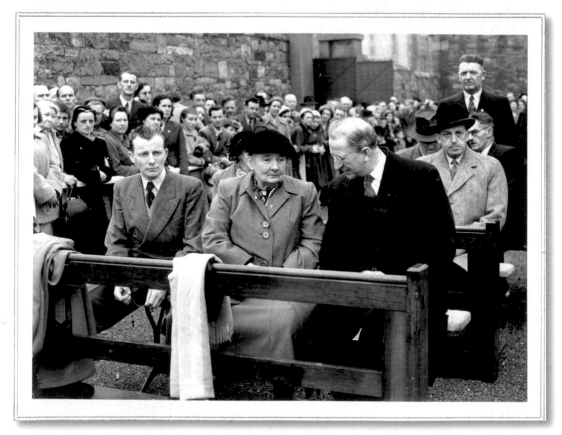

Pearse's sister Mary Brigid was a talented musician and aspiring writer. She published two books during her lifetime, a novel entitled *The Murphys of Ballystack* and *The Home-Life of Pádraig Pearse*, which consisted of an edited version of her brother's unfinished autobiography accompanied by reminiscences of him by friends and family. At the end of the biography she wrote, 'My brother's diary ends abruptly here. I am very sorry that it has ended; for I have a curious blank feeling, as if some pleasant confidential voice had suddenly grown silent.'

Mary Brigid's behaviour could often be eccentric and it would seem that she may have had mental health problems over the course of her life. She became increasingly estranged from her surviving sister, Margaret, following the death of their mother. They quarrelled over the publication of *The Home-Life of Pádraig Pearse* and a court battle between the sisters was only averted at the last minute. Mary Brigid died in 1947.

Mary Brigid Pearse (ed.), *The Home-Life of Pádraig Pearse*, p. 40

Thomas Clarke's idea that Pearse would provide a 'respectable' figurehead for the Rising proved most accurate. Pearse was adopted as an appropriate founding father for the new State. He was cultured, Irish-speaking and a devout Catholic. Also, with the exception of Connolly, Pearse was the only leader to leave behind a written legacy of his political ideas and aspirations. Those seeking to understand the meaning and ideals of the 1916 Rising inevitably turned to the considerable body of writing he published just prior to the event.

Given the heavy religious undertones of much of his writing, it is perhaps not surprising that the image of him which emerged was that of an heroic and somewhat otherworldly figure. This is particularly reflected in the images of him produced after his death. His famous side-profile took on an iconic quality more associated with a saint or deity.

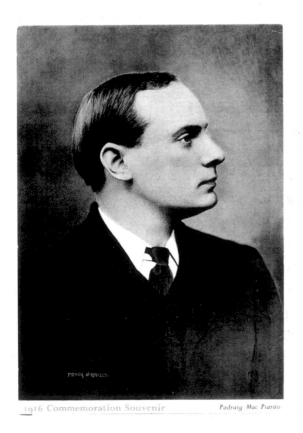

1916 Commemoration Souvenir *Padraig Mac Piarais*

CONCLUSION

Pearse was a deeply revered figure in the early years of the Irish State and was promoted as the embodiment of the hopes and ideals of the newly emerging nation. Both sides of the political divide attempted to present themselves as his successors and his name was frequently evoked in the Dáil chamber to add legitimacy to a particular opinion. Parks, schools, roads, streets, stadiums, sports clubs and a train station were named after the Pearse brothers, including the street where they were born. Patrick's cottage in Rosmuc was restored in 1964, and his school and final home in The Hermitage, Rathfarnham, was opened to the public on the centenary of his birth in 1979. His birthplace is now a cultural centre. Cullenswood House is an Irish-speaking primary school. Pearse was by far the most prominent figure during the fiftieth anniversary celebrations of the Rising in 1966. His iconic profile became one of the most identifiable symbols of the Rising and his reputation eclipsed that of many of the other leaders.

However, it was also around the time of the fiftieth anniversary that serious questioning of Pearse and the 1916 Rising began. Some commentators rejected what they saw as Pearse's glorification of violence and the idea of self-sacrifice. The interrogation of Pearse's legacy intensified with the outbreak of the Troubles in Northern Ireland in 1969. The public perception of Pearse suffered as a result of the increasingly bitter and polarised debates that developed between those who defended him with unquestioning devotion and others who sought to undermine his reputation with equal zeal.

The advent of peace in the 1990s has paved the way for a less entrenched, more nuanced debate about Pearse and his legacy. He remains one of the most complex and enigmatic figures in modern Irish history: the champion of all things Irish who had an English father; the advocate of bloody sacrifice who could not bear the suffering of either men or animals; a man who was shy and awkward at social gatherings, but who could also sway a crowd with his words and win the hearts and lifelong devotion of the boys he cared for. We may never truly understand Pearse, but perhaps it is best to remember the words of his former student and first biographer, Desmond Ryan: 'Pearse never was a legend, he was a man.'

Reference: Patrick Pearse, *The Complete Works of P.H. Pearse: The Story of a Success*, p. 131

BIBLIOGRAPHY

An Barr Buadh, 5 April 1912

An Claidheamh Soluis, 23 August 1913

Augusteijn, Joost, 'The Road to Rebellion: The Development of Patrick Pearse's Political Thought, 1879–1914', in Roisín Higgins and Regina Uí Chollatáin (eds), *The Life and After-Life of Patrick Pearse*, Irish Academic Press, Dublin and Portland, 2009

— *Patrick Pearse: The Making of a Revolutionary*, Palgrave Macmillan, London, 2010

Barton, Brian, *From Behind a Closed Door: Secret Court Martial Records of the 1916 Rising*, The Blackstaff Press, Belfast, 2002

Beatrice, Lady Glenavey, *Today We Will Only Gossip*, Constable and Company, London, 1964

The Catholic Bulletin and Book Review, Vol. VII, No. 4, April 1917

Colum, Mary, *Life and the Dream*, Doubleday and Company Inc., New York, 1947

Coogan, Tim Pat, *1916: The Easter Rising*, Cassell & Co., Dublin, 2001

Cooke, Pat, *Scéal Scoil Éanna. The Story of an Educational Adventure*, Office of Public Works, Dublin, 1986

— 'Patrick Pearse, The Victorian Gael', in Roisín Higgins and Regina Uí Chollatáin (eds), *The Life and After-Life of Patrick Pearse*, Irish Academic Press, Dublin and Portland, 2009

Corlett, Christiaan, *Darkest Dublin: The Story of the Church Street Disaster and a Pictorial Account of the Slums of Dublin in 1913*, Wordwell, Dublin, 2008

Crowley, Brian, 'His Father's Son: James and Patrick Pearse', in *Folk Life, Journal of Ethnological Studies*, Vol. 43, 2004–5

— 'I Am the Son of a Good Father: James and Patrick Pearse', in Roisín Higgins and Regina Uí Chollatáin (eds), *The Life and After-Life of Patrick Pearse*, Irish Academic Press, Dublin and Portland, 2009

Czira, Sydney Gifford [John Brennan], *The Years Flew By*, Gifford and Craven, Dublin, 1974

Edwards, Ruth Dudley, *Patrick Pearse: The Triumph of Failure*, Poolbeg Press, Dublin, 2006

Fennessy, Ignatius, 'Patrick Pearse and the Four (or Five) Masters', in *The Donegal Annual/Bliainiris Dhún na nGall: Journal of the County Donegal Historical Society*, No. 53, 2001

Higgins, Roisín, 'Remembering and Forgetting P. H. Pearse', in Roisín Higgins and Regina Uí Chollatáin (eds), *The Life and After-Life of Patrick Pearse*, Irish Academic Press, Dublin and Portland, 2009

Higgins, Roisín and Uí Chollatáin, Regina (eds), *The Life and After-Life of Patrick Pearse*, Irish Academic Press, Dublin and Portland, 2009

Kiberd, Declan, 'Patrick Pearse: Irish Modernist', in Roisín Higgins and Regina Uí Chollatáin (eds), *The Life and After-Life of Patrick Pearse*, Irish Academic Press, Dublin and Portland, 2009

Le Roux, Louis N., *Patrick H. Pearse*, translated and adapted by Desmond Ryan, The Talbot Press, Dublin, 1932

MacLochlainn, Piarais, *Last Words, Letters and Statements of the Leaders Executed After the Rising at Easter 1916*, Dúchas, The Heritage Service, Dublin, 2001

Ó Buachalla, Séamas, *The Literary Writings of Patrick Pearse*, Mercier Press, Dublin and Cork, 1979

— *Pádraig Mac Piarais agus Éire lena linn*, Mercier Press, Dublin and Cork, 1979

— *A Significant Irish Educationalist: The Educational Writings of P. H. Pearse,* Mercier Press, Dublin and Cork, 1980

— *The Letters of P. H. Pearse,* Colin Smyth, London, 1980

Ó Conaire, Pádraic Óg, 'Cuimhní Scoil Éanna', *Cuimhní na bPiarsach,* Dublin, 1958

O'Neill, Éamonn, 'Patrick Pearse: some other memories', in *The Capuchin Annual,* 1935

Padbury, Joyce, 'A Young Schoolmaster of Great Literary Talent: Mary Hayden's Friend, Patrick Pearse', in Roisín Higgins and Regina Uí Chollatáin (eds), *The Life and After-Life of Patrick Pearse,* Irish Academic Press, Dublin and Portland, 2009

Pearse, Margaret, 'Patrick and Margaret Pearse', in *The Capuchin Annual,* 1943

— 'The Last Days of Pat and Willie Pearse at St. Enda's', in *Leabharán Cuimhneacháin arna Fhoilsiú ar Ócáid Bronnadh Eochar Scoil Éanna ar Uachtarán na hÉireann Eamon De Valera 23 Aibreán 1970*

Pearse, Mary Brigid (ed.), *The Home-Life of Pádraig Pearse,* Browne and Nolan, Dublin, 1935

Pearse, Patrick, 'Fragment of Autobiography' (unpublished manuscript held in the Pearse Museum PMSTE.2003.0946, no date)

— *An Macaomh,* Midsummer 1909; Christmas 1909; Christmas 1910; May 1913

— *The Complete Works of P.H. Pearse: Political Writings and Speeches,* Phoenix Press, Dublin, 1924

— *The Complete Works of P.H. Pearse: Poems, Plays, Stories,* Phoenix Press, Dublin, 1924

— *The Complete Works of P.H. Pearse: The Story of a Success,* edited by Desmond Ryan, Phoenix Press, Dublin, 1924

— *The Coming Revolution: Political Writings of Patrick Pearse,* Mercier Press, Cork, 2012

Reddin, Kenneth, 'A Man Called Pearse', in *Studies,* June 1943

Ryan, Desmond, *A Man Called Pearse,* Maunsel Press, Dublin and London, 1919

— *The Story of a Success: being a Record of St. Enda's College September 1908 to Easter 1916,* Maunsel Press, Dublin and London, 1919

— *Remembering Sion: A Chronicle of Storm and Quiet,* Arthur Barker, London, 1934

Scoil Éanna Prospectus 1908–9

Sisson, Elaine, *Pearse's Patriots: St Enda's and the Cult of Boyhood,* Cork University Press, Cork, 2004

— 'Masculinity and Citizenship; Boyhood and Nationhood at St. Enda's', in Roisín Higgins and Regina Uí Chollatáin (eds), *The Life and After-Life of Patrick Pearse,* Irish Academic Press, Dublin and Portland, 2009

Uí Chollatáin, Regina, 'The History of a Century in a Generation: The Perspective of an Irish Journalist, P.H. Pearse', in Roisín Higgins and Regina Uí Chollatáin (eds), *The Life and After-Life of Patrick Pearse,* Irish Academic Press, Dublin and Portland, 2009

Walsh, Brendan, *The Pedagogy of Protest: The Educational Thought and Work of Patrick H. Pearse,* Peter Lang, Bern, 2007

— 'Radicalising the Classroom: Pearse and the Pedagogy of Progressivism', in Roisín Higgins and Regina Uí Chollatáin (eds), *The Life and After-Life of Patrick Pearse,* Irish Academic Press, Dublin and Portland, 2009

Williams, Jeremy, *A Companion to Architecture in Ireland, 1837–1921,* Irish Academic Press, Dublin, 1994

Young, Ella, *Flowering Dust,* Longmans Green and Co., New York and Dublin, 1945